350265

Charing Cross

D1465552

Nils Norman

Serpentine Gallery | **Koenig Books**

Foreword

Charing Cross is one of a series of ambitious projects initiated by the Serpentine Gallery through its Education and Public Programmes. The Serpentine established a relationship with The Connection at St Martin-in-the-Field, one of the UK's largest homeless organisations, to consider how an artist might respond to the centre's unique context in central London. The Serpentine and The Connection at St Martin's invited artist Nils Norman to work with staff and service users to develop a new commission. Serpentine Gallery Projects are defined by an engagement with a specific context. In response to the fluid nature of the centre and against the backdrop of a major building project at The Connection at St Martin's, over two years Norman developed an open structure that allowed many people to contribute their knowledge of the Charing Cross area. The project was developed to pilot the model of the Fondation de France's New Patrons Scheme within the UK.

Norman presents *Charing Cross*, an idiosyncratic exploration of historical concepts of homelessness, and how the economic and physical structures of the city impact upon people who inhabit its public space. *Charing Cross* is a poetic mapping of the artist's encounters, experiences and research during the course of his residency, with drawings, maps and diagrams by people at The Connection at St Martin's as well as references to historical and factual material.

First and foremost, we are deeply grateful to Nils Norman for his dedication to the project and for realising this new work. His commitment and distinctive approach to this commission has produced a truly unique publication.

We are indebted to Colin Glover, Chief Executive, and the staff of The Connection at St Martin's, for their unwavering energy and support for this work, particularly against the disruptions of their building project. We are also especially grateful to Susan Eskdale, former Arts Co-ordinator, who has been central to the project; Wyn Newman, User Participation and Development Manager; Dawn Ogunbiyi, Oral History Project Leader and participants of Homeless in the Capital: Oral History Project. The Serpentine would also like to thank everyone at The Connection at St Martin's who has contributed material to this publication.

We would like to extend our enormous appreciation to everyone who agreed to be interviewed by Nils Norman: John Bird MBE, Founder and Editor-In-Chief of *The Big Issue*; Paul Chatterton, Senior Lecturer in Urban Geography at Leeds University; Rosalyn Deutsche, cultural theorist and Visiting Professor, Barnard College, New York; David Harvey, Distinguished Professor of Anthropology at CUNY Graduate

Center, New York; Doreen Massey, Professor of Geography at the Open University; Alan Moore, writer and magician; Iain Sinclair, novelist and film-maker; Neil Smith, Distinguished Professor of Anthropology and Geography at CUNY; and Sharon Zukin, Broeklundian Professor of Sociology at Brooklyn College and CUNY Graduate Center.

We would also like to thank Teresa Gleadowe, curator, who as Director of the Curating Contemporary Art MA, Royal College of Art, initiated this collaboration with Fondation de France, and to Mariana Cánepa Luna, former Fondation de France Curatorial Fellow at the Serpentine Gallery, who developed the project in its initial stages.

We are grateful to Llinos Thomas, Local Studies Librarian at Westminster City Archives, as well as to Ashley Siple, for their assistance with Nils Norman's research.

We are indebted to Bloomberg, in particular Jemma Read, who have been long-standing supporters of the Serpentine Gallery's Education Projects. Their steadfast support has enabled this programme to develop in a truly ambitious way.

We are thrilled to have had the opportunity to work with the Fondation de France on this first UK project in the New Patrons programme and we cannot thank enough Catia Riccaboni, who is responsible for the cultural programme at the Fondation, François Hers, artist and founder of the New Patrons Scheme, and the Board of the Fondation de France, for their vision and generous association with this project.

Our thanks also go to Keith Sargent of immprint, who has worked with Nils Norman on the design of the publication, and to Lucie Ewin of Rook Books for her guidance and editorial skills. We are also indebted to Franz König for his invaluable support and expertise as well as to the whole publications team at Verlag der Buchhandlung Walther König.

Finally, we would like to express our thanks to our colleagues Sally Tallant, Head of Programmes, and Louise Coysh, Project Organiser, whose pioneering work has been crucial to the realisation of this project and also to Ben Fergusson, Print and Publications Manager, for his assistance with the production of this publication.

Julia Peyton-Jones
Director, Serpentine Gallery
and Co-Director, Exhibitions
and Programmes

Hans Ulrich Obrist
Co-Director, Exhibitions and
Programmes and Director of
International Projects

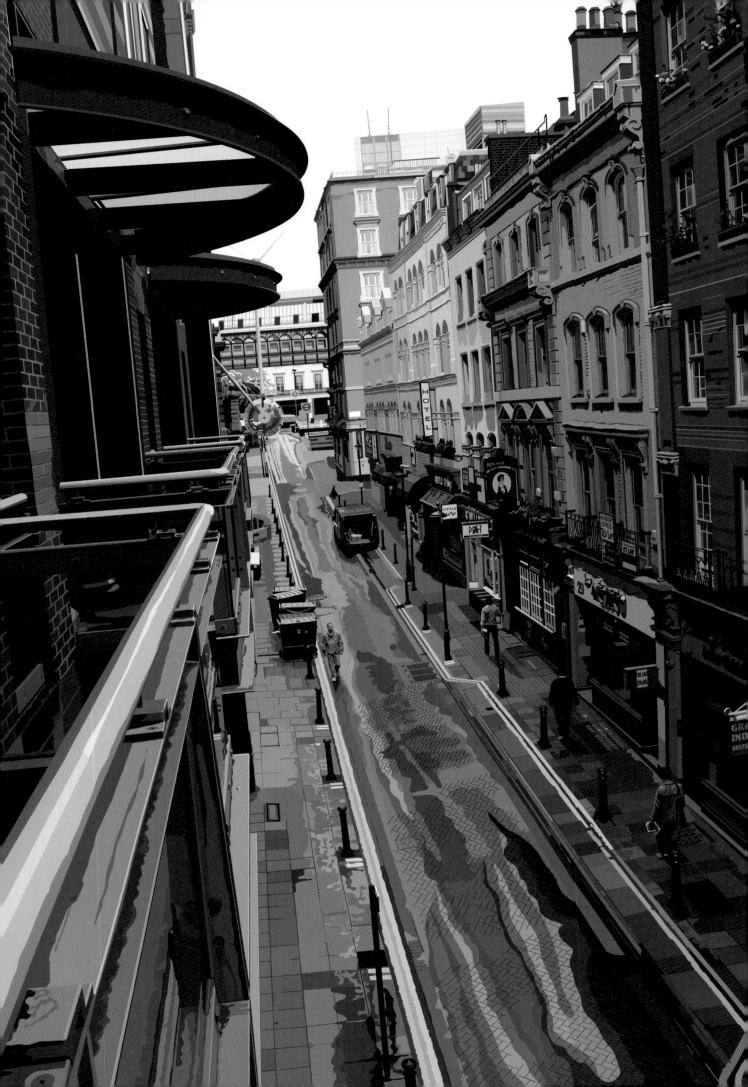

practices, from the Anabaptist tradition, it was an affirmation of human equality, a revolt against class.[3]

The fight between Parliament and King in the Civil War also produced a third group, aligned to neither Cavalier nor Roundhead. This group slowly grew in importance as the war (and the uneasy peace) destabilized English society. Its leader was John Lilburne and its 'party' was called the Levellers. Lilburne was born the son of a County Durham family with connections at court and a second home in the Palace at Greenwich. Whilst his family had land and money, John, a junior member, always had to earn a living and spent his often interrupted working life (for most of it he was in prison) trying to make ends meet manufacturing soap and brewing ale in Southwark. He was not particularly good at either. He never forgot, however, that he was no mere tradesman. 'I am the Sonne of a Gentleman, and my friends are of rancke and quality,' he would insist.

Lilburne's London was a thriving and vibrant city. Its 250,000 inhabitants sprawled across five miles of land on the north bank of the Thames and three on the south. Ferries transported those who could not cross by London's single bridge, and 3,000 watermen (the seventeenth-century taxi drivers) made a living on the river. The wharves were packed with every sort of import and export and ships docked many deep awaiting lightermen to take off their goods. In the east, the old City now joined Westminster by numerous roads and Charing Cross was no longer an isolated village oasis.*

* The village of Charing sat between the City and Westminster and was marked at its extreme western edge by the 'Eleanor' Cross removed to make way for the equestrian statue of Charles I which still marks the meeting of Charing Cross Road and Whitehall and where Oliver Cromwell had his town house. To the east, the great houses of the nobility looked towards the Thames, yet one by one Bedford House, Arundel House, and York House, with their elegant waterfront stairs and private barges, fell into disrepair, were partitioned or redeveloped. Only Somerset House survived, as did the Duke of Buckingham's water stairs at York House. Modern roads recall many of the older palaces and many houses still hark back to the seventeenth century when Pepys lived on the waterfront. In their place arose the elegant and highly fashionable 'Adelphi', built by the Adam brothers as a speculation and soon home to many of London's celebrities, including Samuel Johnson, Sir Richard Arkwright and visitors such as Benjamin Franklin. The Royal Society for the encouragement of Arts, Manufacture and Commerce (RSA) still exists housed in its original building from the 1790s, within the walls of which the Great Exhibition of 1851 was first thought up. It was here also that Charles Dickens worked as a child in the famous 'blacking' factory to the west of the Adelphi at Hungerford Stairs near Hungerford House, itself demolished to make way for Charing Cross Station outside which a new 'cross' was erected. The original complex waterfront was finally destroyed with the coming of Bazalgette's Embankment project, which destroyed the riverside terrace of the Adelphi but left the complex of wine cellars that extends under many of the buildings that still exist. Covent Garden, built by the Russell family after the Great Fire, was intended as an elegant piazza linked to the old Delphi riverside community.

Glossary

Affordable housing
Subsidised housing at below market prices or rents, intended for households that cannot afford housing at market rates. Usually managed by a registered social landlord.

Appearance
The look, aspect and visual character of a building, area or city.

Biodiversity
The variety of plants, animals and other living things in a particular locality. It encompasses habitat diversity, species diversity and genetic diversity. Arising from a belief that biodiversity is of value in its own right and has social and economic value for human society, international treaties and national planning policy expect local development plans to identify and protect a hierarchy of existing areas of biodiverse importance and to provide for the creation of new priority habitats.

Bollards
Rigid posts that can be arranged in a line to close a road or path in order to block vehicles above a certain width. Bollards can be mounted near enough to each other that they block ordinary cars, for instance, but far enough apart to allow special-purpose vehicles through. Bollards can be used to enclose car-free zones and can be removable to allow access for service and emergency vehicles.

Bohemians
A term used to describe people who live an unconventional artistic life, in which self-expression is considered a main aim of their work. Art (in its broadest sense) is considered a serious, if not central, part of their life.

Broken windows theory
A successful strategy for preventing vandalism by fixing problems quickly before vandalism escalates. The theory proposes that by repairing broken windows immediately, vandals are much less likely to break more windows or do further damage. There are two major claims at the heart of implementing broken windows theory: further petty crime and low-level anti-social behaviour will be deterred, and major crime will, as a result, be prevented.

Bum-free seats
Street-design deterrents that have appeared in many cities globally and are often located in public squares, streets, public transport stations and parks. The 'bum-free' or 'bumproof' bench has many

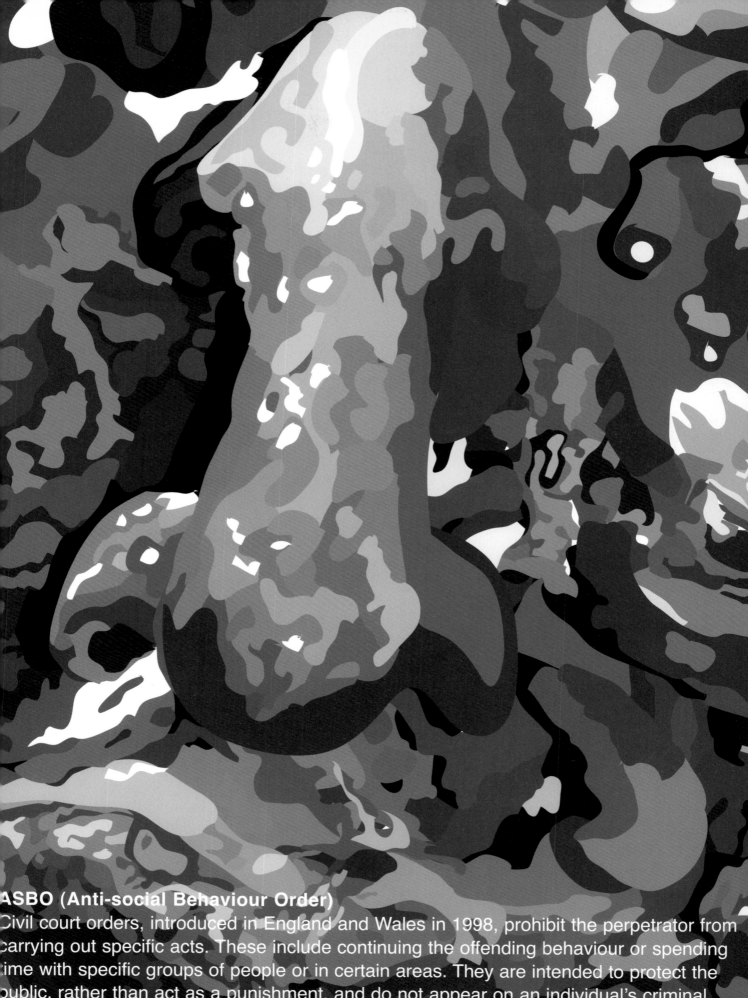

ASBO (Anti-social Behaviour Order)
Civil court orders, introduced in England and Wales in 1998, prohibit the perpetrator from carrying out specific acts. These include continuing the offending behaviour or spending time with specific groups of people or in certain areas. They are intended to protect the public, rather than act as a punishment, and do not appear on an individual's criminal record, though breaking an ASBO is a criminal offence. ASBOs are issued for a minimum of two years.

different designs. The main object is to prevent users from lying down or sitting in any comfort for long periods. Recent developments include single seats and the 'perch', often found in bus stations.

Business Improvement District (BID)

An area, defined under Part 4 of the Local Government Act 2003, where businesses, through a partnership arrangement, contribute an annual levy over a period of up to five years. The aim is to provide funds to secure environmental improvements, to enhance local services, such as street cleaning, and to carry out economic development activities within the area.

Character

The distinctive or typical quality of a building or area, as defined by its historic fabric, appearance, townscape, and land uses.

Cherished item

Historically, architecturally and/or artistically important items of street furniture and surface materials, which are valued for their distinctive character and their aesthetic and cultural contribution to the street scene. This will include all items of listed street furniture, and various non-listed items, that make a unique contribution to place and which should normally be retained.

Chuggers or Charity Muggers

Individuals who are paid by charities to sign up passers-by for monthly direct debits to the charity. 'The chuggers, with their laminate clipboards, who are now a type of pestilence...'[1]

The creative class

Professor Richard Florida developed the theory of a 'creative class', which he proposed as a key driving force for economic development in post-industrial cities and who city planners must attract in order to regenerate and invigorate urban economic areas. The group is split into 'creative professionals' and the 'super-creative core'. The first group comprises knowledge workers and can be expanded to include lawyers and physicians. The second is roughly 12% of the US workforce and includes architects, computer programmers, media workers and those working in education.

Curtilage

Land which is attached to a building, creating a single enclosure.

1. Iain Sinclair, author interview, 2007

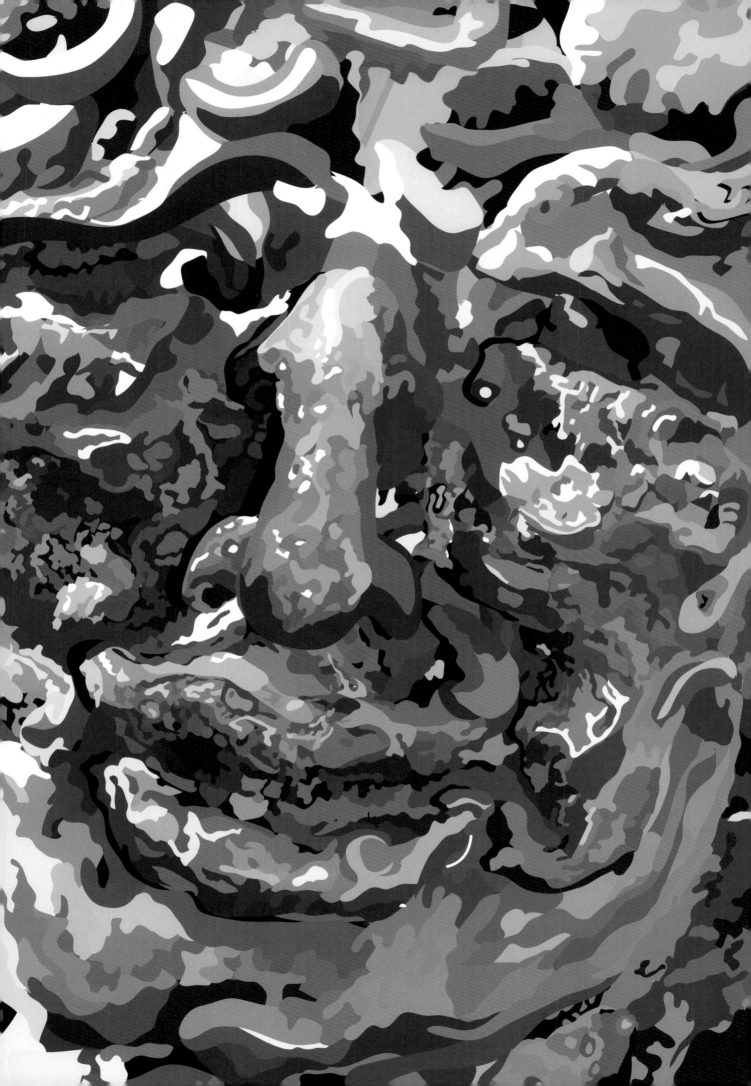

Library & Learning Centre
University for the Creative Arts

Dead frontage
Frontage in a shopping area that generates a low level of shopping activity, because of the use or appearance of the premises concerned.

Defensive design
In a general sense, design that takes account of ways in which misuse of the final product or scheme may be avoided. In the context of homelessness, this relates to the use of street and building furniture to prevent an area being used for sleeping in or used in a way that might be considered 'anti-social'. Preventative measures include use of lighting, building surfaces with steep angles, studded or uneven flooring in accessible recesses, barriers, spiked railings and anti-climb paint.

Exclusion zones
The existence of exclusion zones is based on court rulings that allow the government to regulate the time, place and manner of protests. In these areas, it is illegal for people to practice their right to protest or right of free speech. In London, current exclusion zones include a 1km area around the Houses of Parliament and the area directly outside the US Embassy.

Feeder pillars
Unsightly cabinets and boxes housing equipment where electrical connections are made. Generally elevated above footway level to keep equipment dry.

Form
The layout (structure and urban grain), density, scale (height and massing), appearance (materials and details) of buildings and developments.

Gentrification
Coined by the sociologist Ruth Glass, in London 1964: 'One by one, many of the working-class quarters of London have been invaded by the middle classes – upper and lower. Shabby, modest mews and cottages – two rooms up and two down – have been taken over, when their leases have expired, and have become elegant, expensive residences ... Once this process of "gentrification" starts in a district it goes on rapidly until all or most of the original working-class occupiers are displaced and the whole social character of the district is changed.'[1]

1. Ruth Glass, *London: Aspects of Change*, Macgibbon & Kee, London, 1964

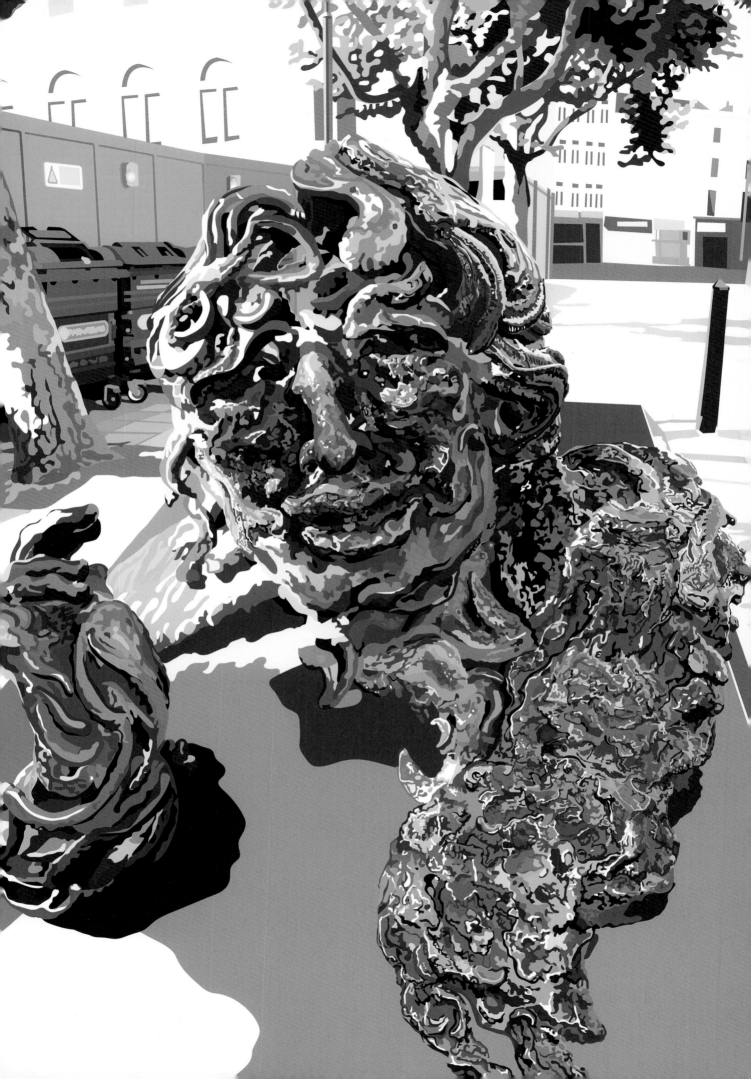

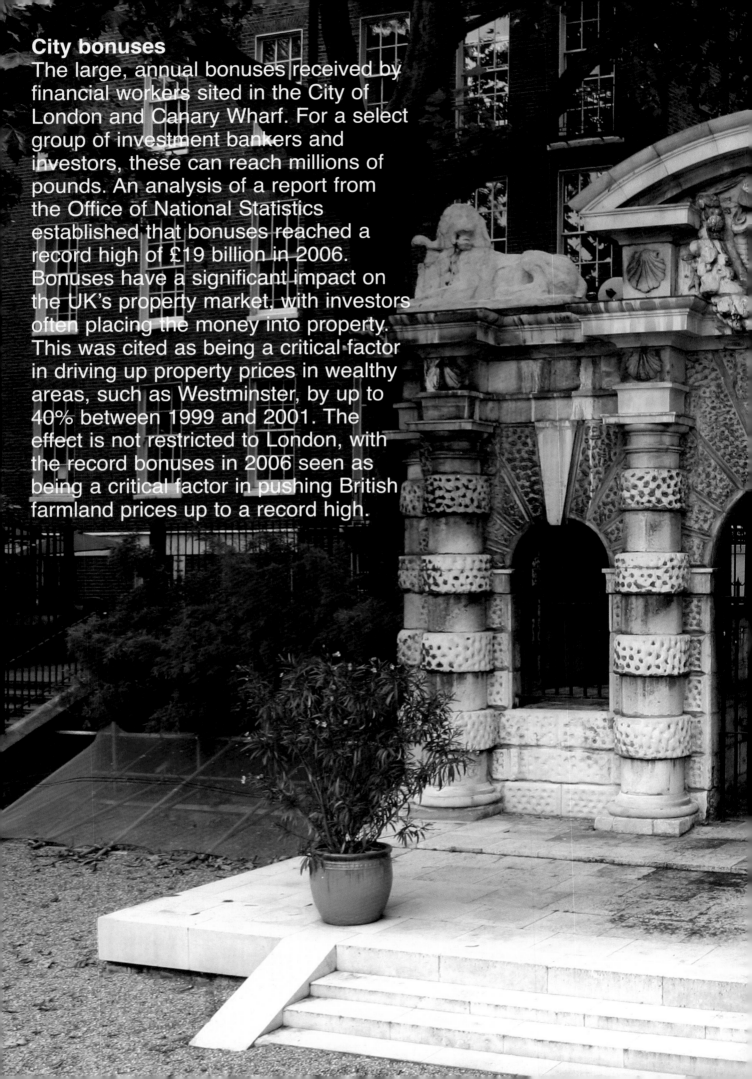

City bonuses

The large, annual bonuses received by financial workers sited in the City of London and Canary Wharf. For a select group of investment bankers and investors, these can reach millions of pounds. An analysis of a report from the Office of National Statistics established that bonuses reached a record high of £19 billion in 2006. Bonuses have a significant impact on the UK's property market, with investors often placing the money into property. This was cited as being a critical factor in driving up property prices in wealthy areas, such as Westminster, by up to 40% between 1999 and 2001. The effect is not restricted to London, with the record bonuses in 2006 seen as being a critical factor in pushing British farmland prices up to a record high.

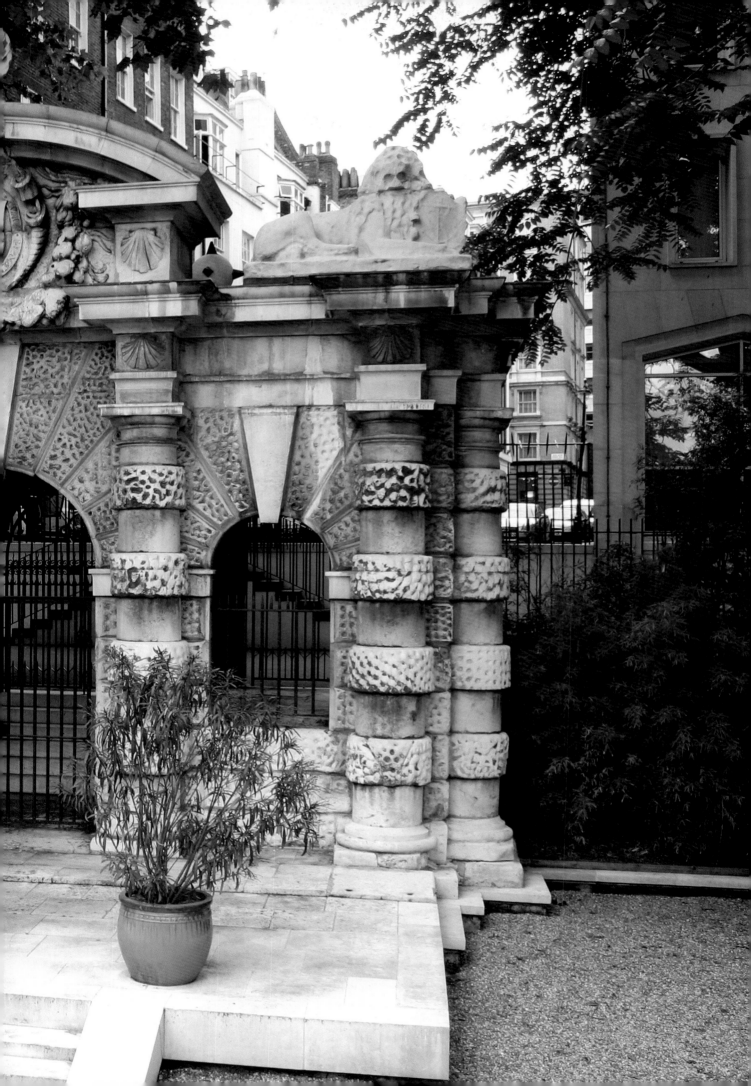

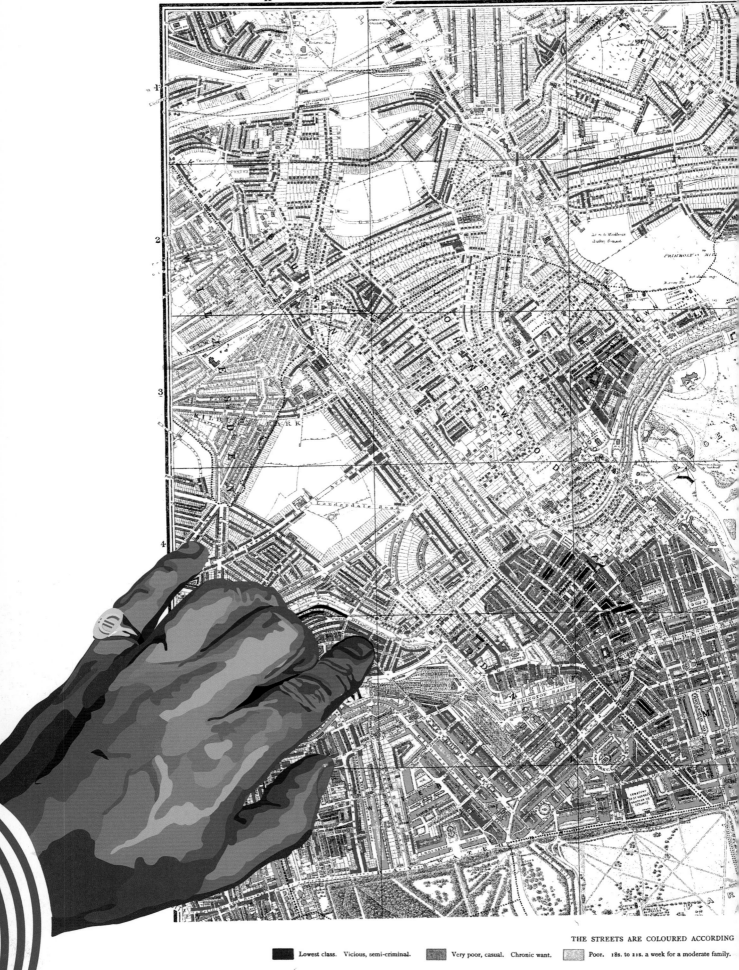

THE STREETS ARE COLOURED ACCORDING

Lowest class. Vicious, semi-criminal.

Very poor, casual. Chronic want.

Poor. 18s. to 21s. a week for a moderate family.

ON POVERTY 1889.

's Hanover Square, Westminster, Strand, Holborn and Islington; the whole of St. Giles's and
ancras.

D E F

NDITION OF THE INHABITANTS, AS UNDER:—

mfortable, other poor. Fairly comfortable. Good ordinary earnings. Well-to-do. Middle class. Upper-middle and Upper classes.
 Wealthy.

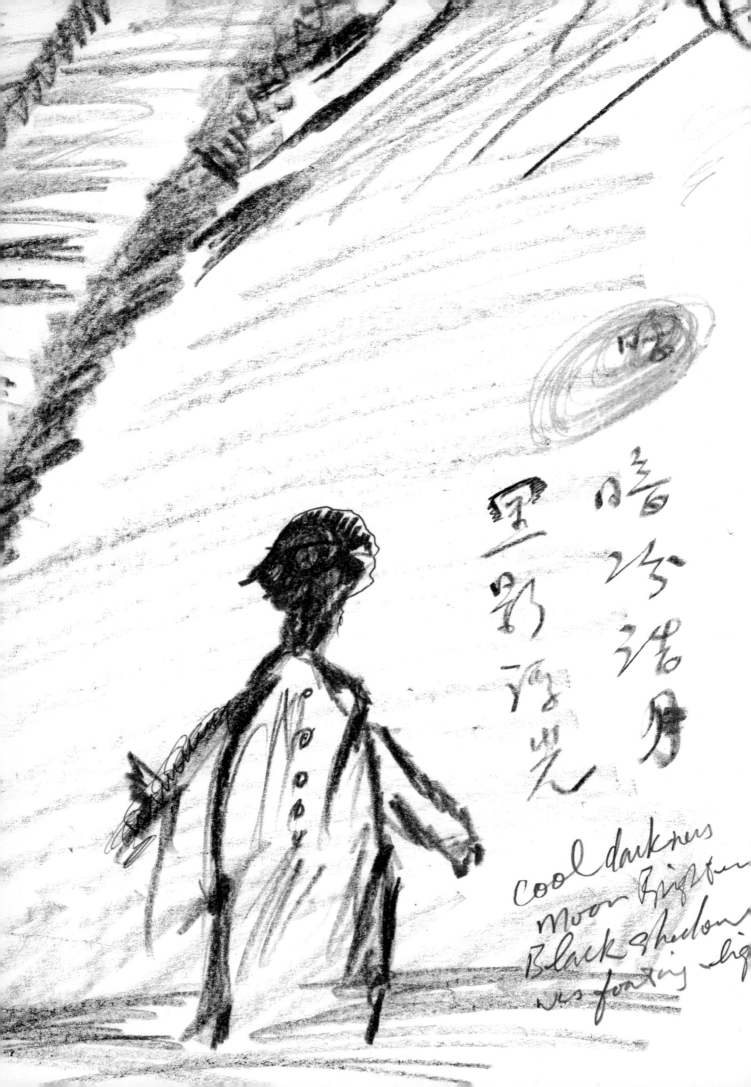

Library & Learning Centre
University for the Creative Arts

Habitable rooms per hectare (hr/h)

A formula used to calculate residential density. Habitable rooms include all living rooms, bedrooms and kitchens, if the latter include dining space and are more than 12.6 sq m (140 sq ft). Bathrooms, toilets, landings and lobbies are excluded. The site area is calculated by including half the width of the adjoining road(s) to a maximum of 6 m (20 ft).

Hipsterization strategies

These are urban-renewal strategies that encourage people – especially young people – to be more interested in living, working and shopping in cities. The idea is to create more attractive urban environments to lure 'bohemians' and the 'creative class'.

Homelessness

A commonly used, contemporary definition for people who lack permanent or fixed housing; the reason is generally thought to be the inability to afford regular, safe accommodation. However, reasons are hugely varied and can include mental illness, an unstable home life (possibly involving domestic abuse) and problems adjusting from other forms of life, such as people who have left the armed forces or prison. The term may also be used to cover people whose primary residence is a homeless shelter or public or private space not intended to be used as regular housing. Some estimates put the figure of worldwide homelessness at 100 million.

Hostel

A building providing residential accommodation, often for a particular group of people, with either board or facilities for the preparation of food. Unlike hotels, they often have no self-contained facilities. Hostels normally provide temporary or short-term accommodation and occupants have no rights of tenure.

Key-worker affordable housing

In the context of London, housing provided for people with skills in an employment sector deemed important to the functioning of Central London with severe difficulties in recruiting and retaining staff. These sectors are currently considered to be health care, policing and education, but this is regularly reviewed.

Local distinctiveness

The positive features of a place and its communities that contribute to its special character and sense of place.

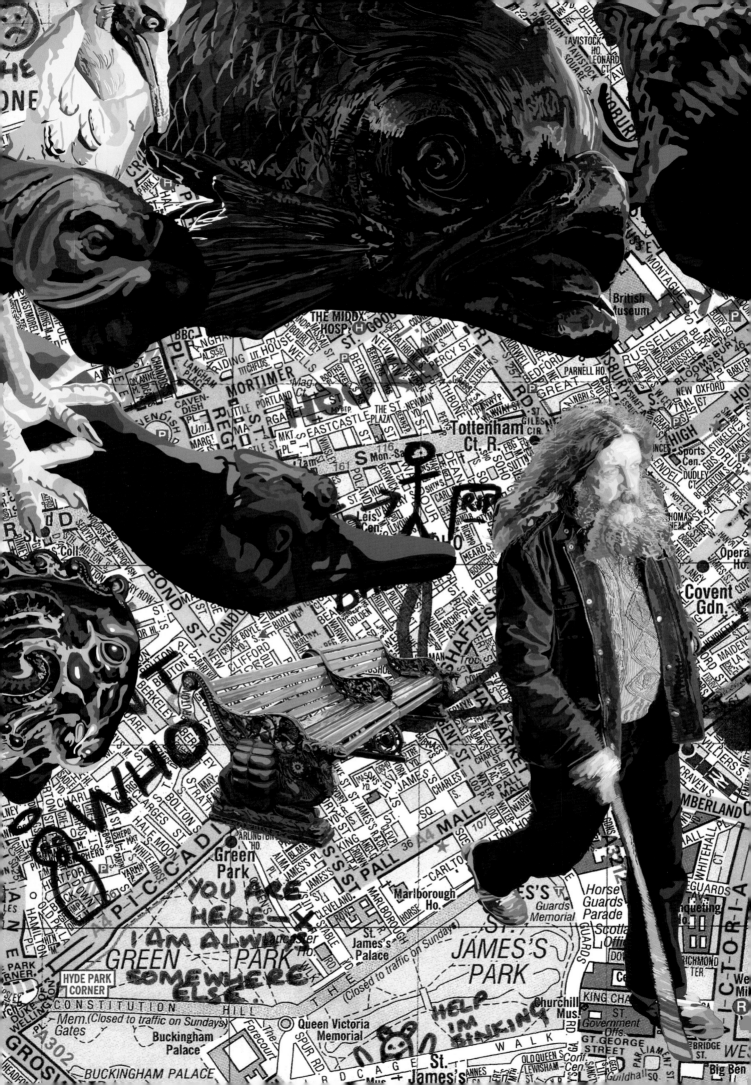

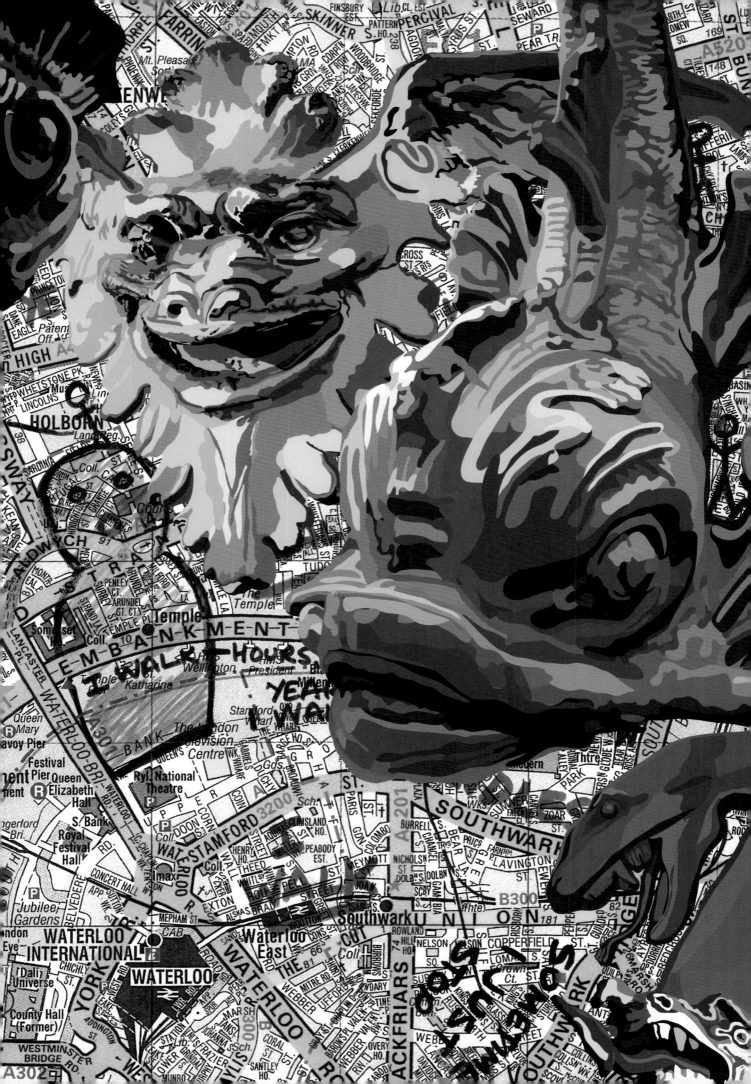

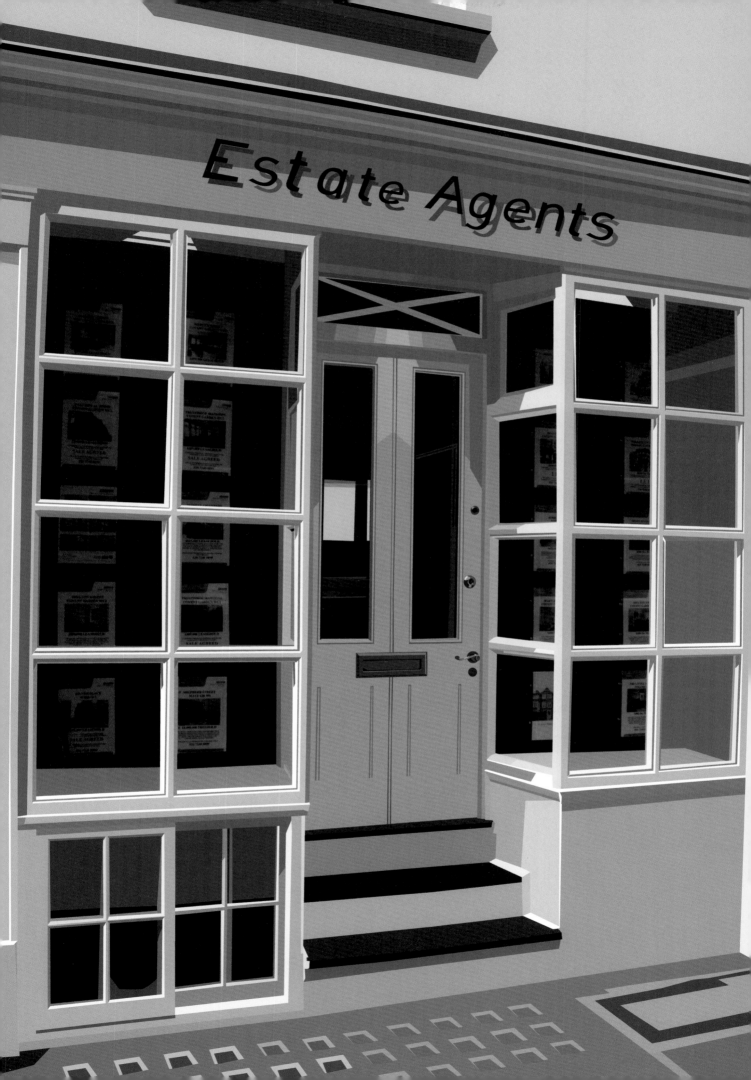

Neoliberalism
Can be defined as: 'Political economic practices that propose that
human well-being can best be advanced by liberating individual
entrepreneurial freedoms and skills within an institutional framework
characterised by strong private property rights, free markets and free
trade. The role of the state is to create and preserve an institutional
framework appropriate to such practices.'[1]

The term used to describe the emergence of an economic policy and
theory that seeks to move the control of the economy from central
government to the private sector. The term is historically specific,
referring to the marked emergence of this idea from the 1970s through
to the 1990s in right-wing circles. The term is generally not used by
those groups to whom it refers and is often used in reference to the
economic policies of Reaganism and Thatcherism.

Odour
Smell or smells usually produced by very small concentrations of
organic vapour.

Out-of-centre
A location more than 200m-300m from the core shopping area of a
shopping centre.

Permeability
The degree to which an area has a variety of pleasant, convenient and
safe routes through it.

Public art
Permanent or temporary works of art visible to the general public,
whether part of a building or freestanding. These can include sculpture,
lighting effects, murals, street furniture, paving, railings and signs.

Public open space
Land, used by the public as gardens or for recreation, which enjoys special
protection. The loss of public, open space is generally not permitted.

Public space
According to Neil Smith and Setha Low public space describes: 'The
range of social locations offered by the street, the park, the media, the
internet, the shopping mall, the United Nations, national governments
and local neighbourhoods. Public space envelops the palpable tension

1. David Harvey, *A Brief History of Neoliberalism*, Oxford, 2005

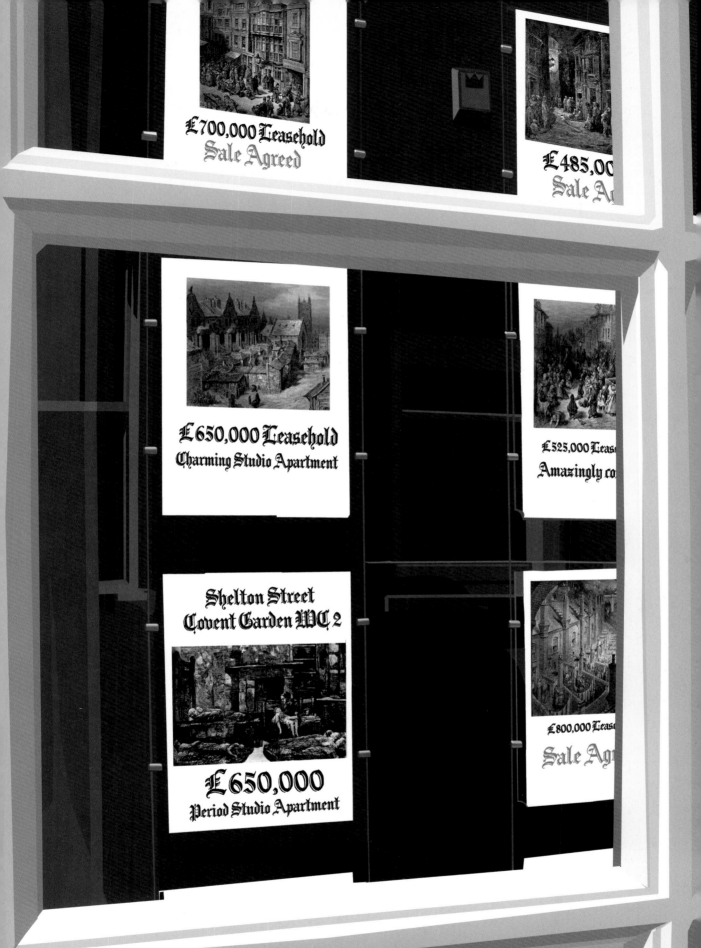

£700,000 Leasehold
Sale Agreed

£485,000
Sale Agreed

£650,000 Leasehold
Charming Studio Apartment

£525,000 Lease
Amazingly co

Shelton Street
Covent Garden WC 2

£650,000
Period Studio Apartment

£800,000 Lease
Sale Agr

£695,000 LEASHOLD
Sale Agreed

£400,000 Freehol

between place, experienced at all scales in daily life, and the seeming spacelessness of the internet, popular opinion, and global institutions and economy. It is also not a homogenous arena: the dimensions and extent of its publicness are highly differentiated from instance to instance. Legally as well as culturally, the suburban mall is a very different place from the national park or the interior of a transnational airliner... Public space includes very recognisable geographies of daily movement, which may be local, regional, or global, but they also include electronic and institutional "spaces" that are every bit as palpable, if experienced quite differently, in daily life.

Public space has very different meanings in different societies, places and times... its meaning today is very much bound up with the contrast between public and private space. It is impossible to conceive of public space today outside the social generalisation of private space and its full development as a product of modern capitalist society.'[1]

Revanchism
The Revanchists were a right-wing political movement in the second half of the nineteenth century in France, built on 'populist nationalism and devoted to a vengeful and reactionary retaking of the country'. Neil Smith reapplies the term to current urbanism: 'This revanchist anti-urbanism represents a reaction against the supposed "theft" of the city... More than anything the revanchist city expresses a race/class/gender terror felt by middle- and ruling-class whites who are suddenly stuck in place by a ravaged property market, the threat and reality of unemployment, the decimation of social services and the emergence of minority and immigrant groups, as well as women, as powerful urban actors. It portends a vicious reaction against minorities, the working class, homeless people, the unemployed, women, gays and lesbians and immigrants.'[2]

Seating
Seating can be a civic asset as well as a cause of civic problems. While providing rest during a journey, and more comfortable access to outdoor spaces for the public, it can also be the focus of what might be considered 'anti-social' behaviour. Examples include providing objects for skateboarders to skate on, rough sleepers to sleep on and groups of young people to congregate around.

1. Neil Smith and Setha Low, *The Politics of Public Space*, Routledge, New York 2006
2. Neil Smith, *The New Urban Frontier: Gentrification and the Revanchist City*, Routledge, New York 1996

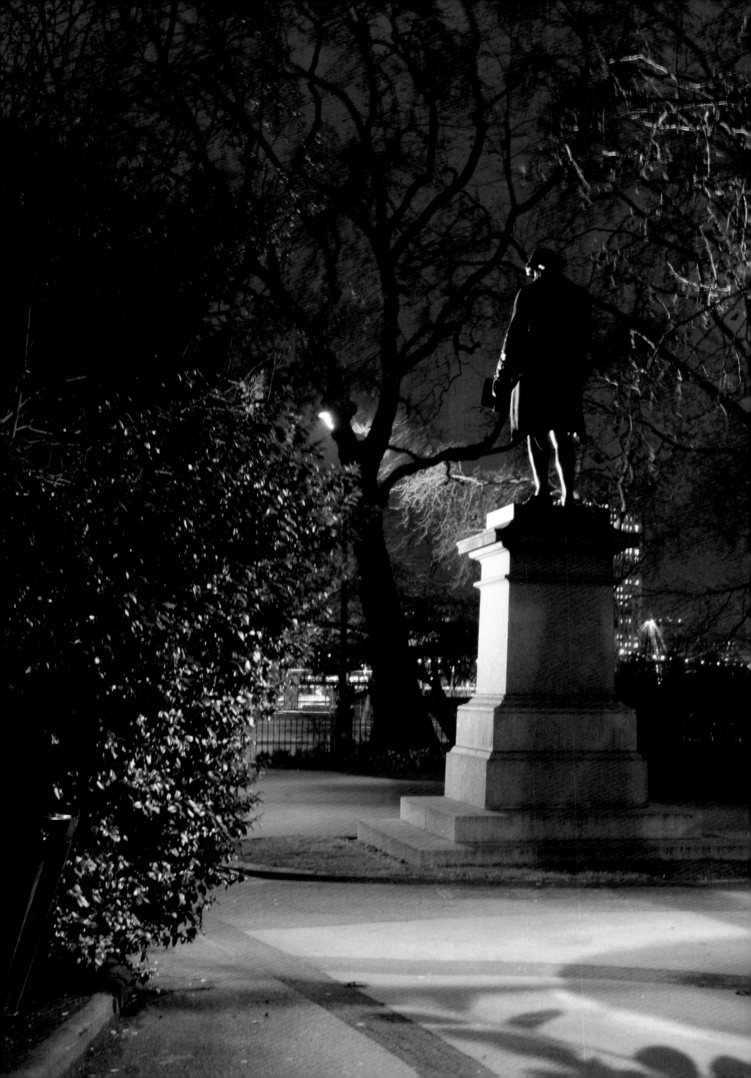

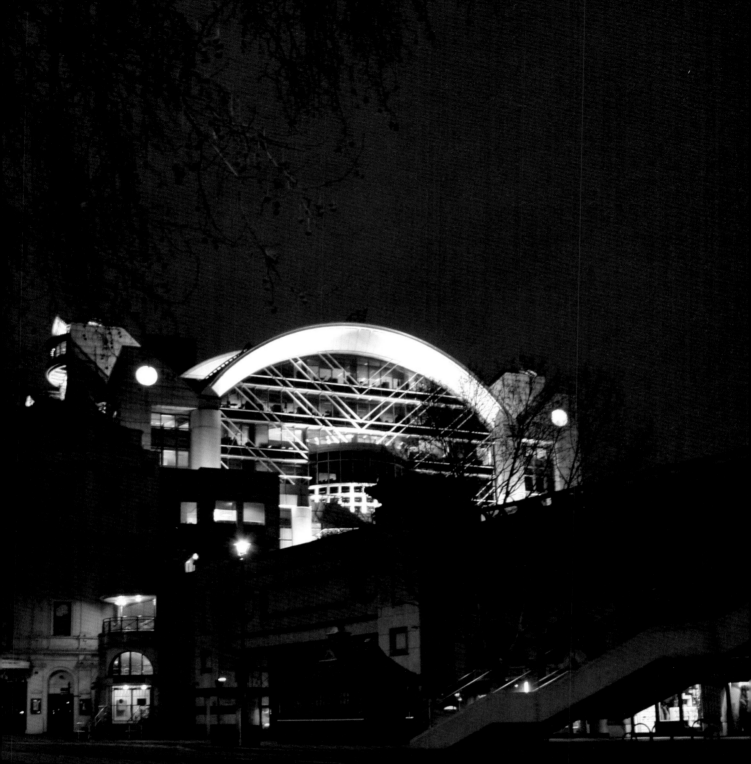

Hierarchy

The physical form of certain parts of the city is organised on a hierarchical basis, from the layout and relationship of squares, streets and mews, to the arrangement of buildings and the order of elements within an individual building. For example, the Portman Square area is organised with the square as the principal focus of space and grand buildings, the secondary and tertiary streets (Baker Street and George Street) then contain buildings of an equivalent status and the mews (Kendal Place) contain the service buildings. The scale and grandeur of buildings reflects the hierarchical plan, with impressive five-storey buildings on the square and simple two-storey buildings on the mews. Each building within this hierarchy is also organised on a hierarchical basis, with windows of diminishing proportion reflecting the status and importance of the floors and rooms.

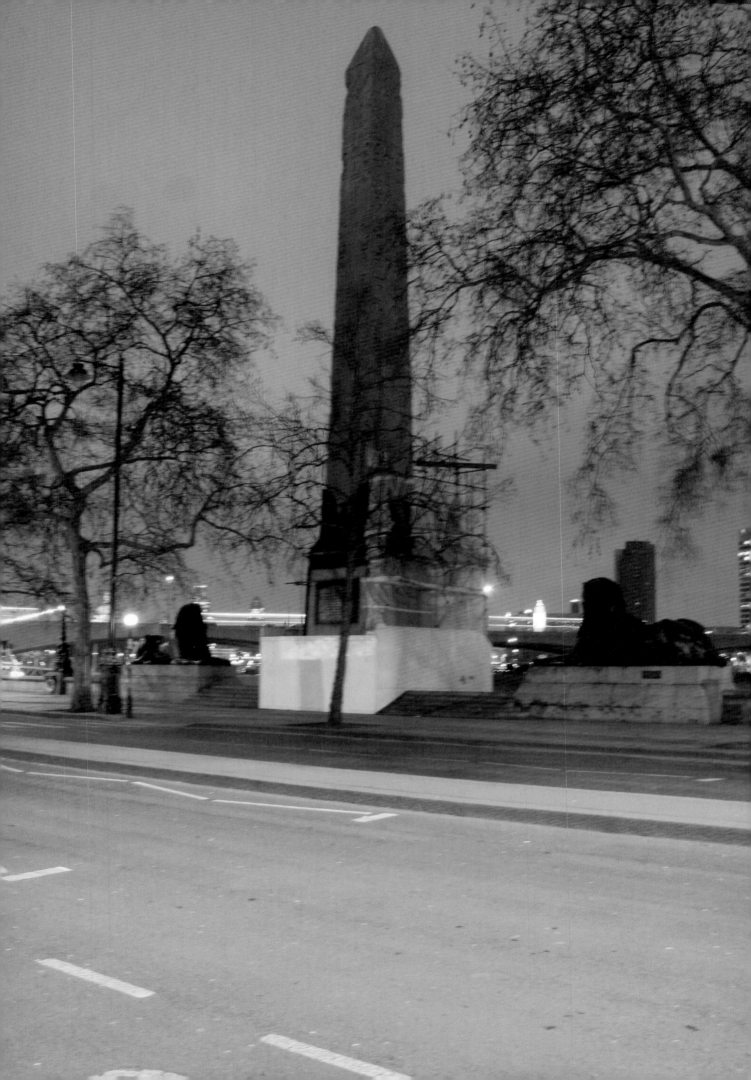

TWEEZER'S ALLEY WC2

CITY OF WESTMINSTER

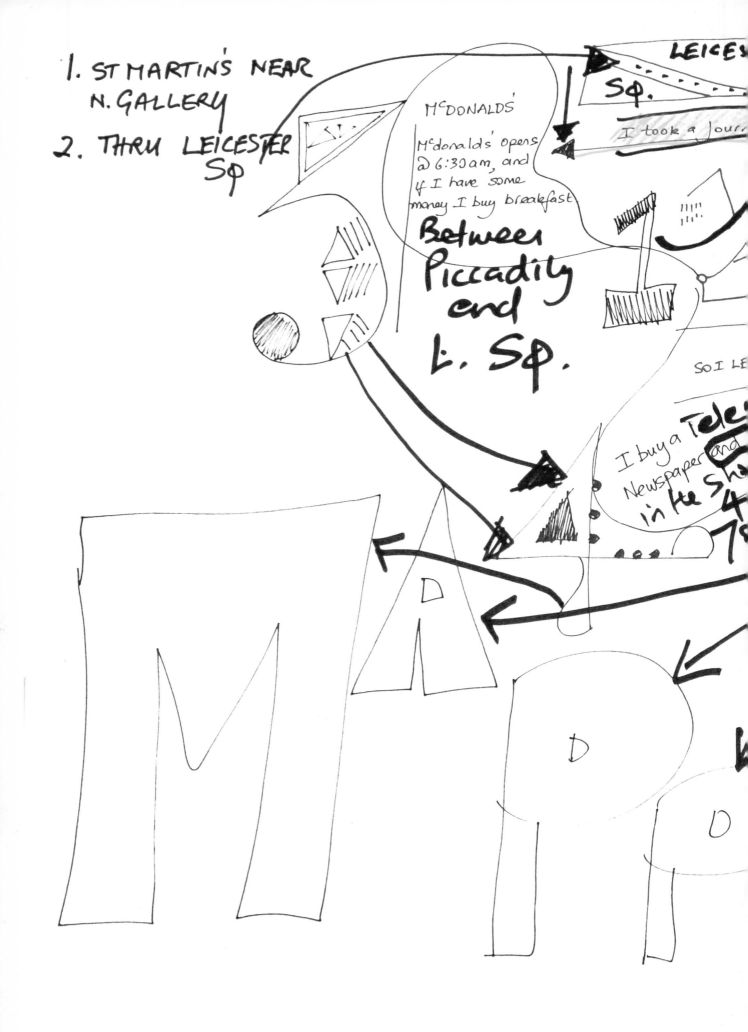

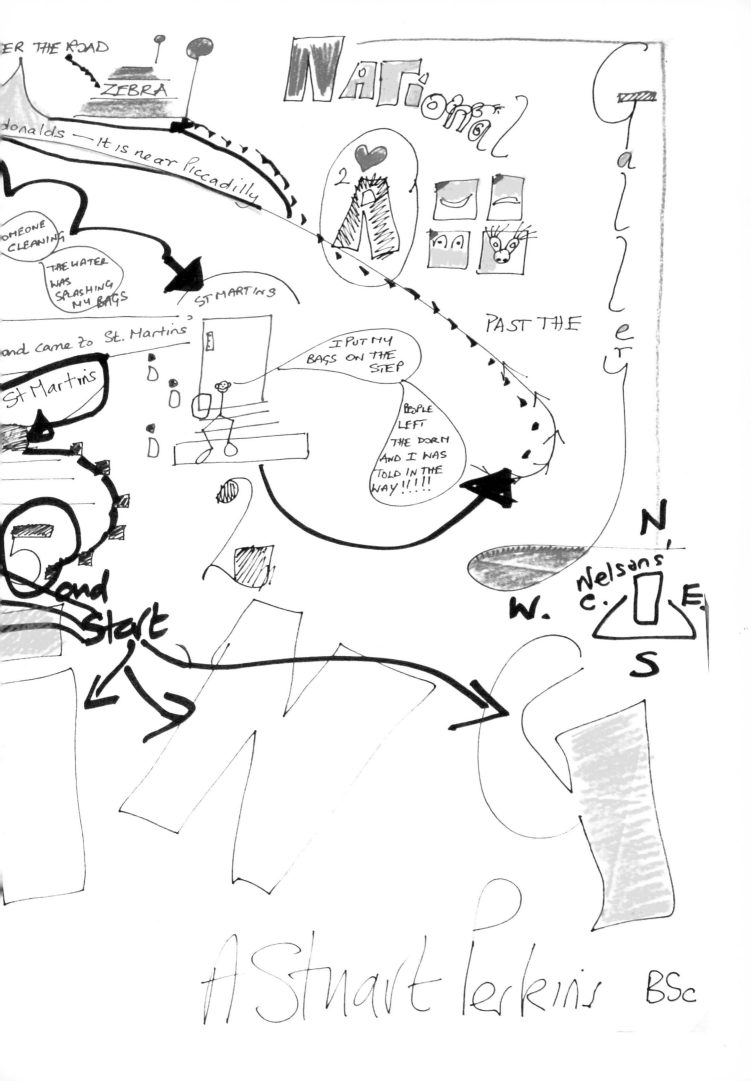

Sense of place
The unique perception or character of a place created by its local buildings, streets, open spaces and activities, which is often greater than the sum of its parts.

Slatted wood bench
An established and familiar bench form, which is easy to maintain and repair. The mid-arms discourage lying down and allow the elderly to push themselves up out of a seated position.

Social housing
Living accommodation, usually rented, provided by a local authority or by a registered social landlord.

Spaces between buildings
The spaces between buildings – streets, open areas and squares – forming the public domain and the 'glue' which binds the townscape.

Stone benches
Stone benches have the advantage of being simple, light in colour and neutral. They have the disadvantages of being cold to the touch, likely to stain and being frequent targets for skateboarders. It is also difficult to repair them and to add armrests to deter sleeping and assist the elderly to get up from a sitting position.

Street furniture
Structures on the street, or on land adjoining it, which contribute to the street scene. Examples include bus shelters, litter bins, telephone kiosks, seating, lighting, railings and signs.

Stress area
An area where the city council believes that restaurants, cafés, takeaways, public houses, bars and other entertainment uses have become concentrated to an extent that harm is being caused to residential amenity, the interests of other commercial uses, the local environment and the character and function of the locality.

Surface treatment
The finishes and materials used to pave the road, pavements and other public open spaces.

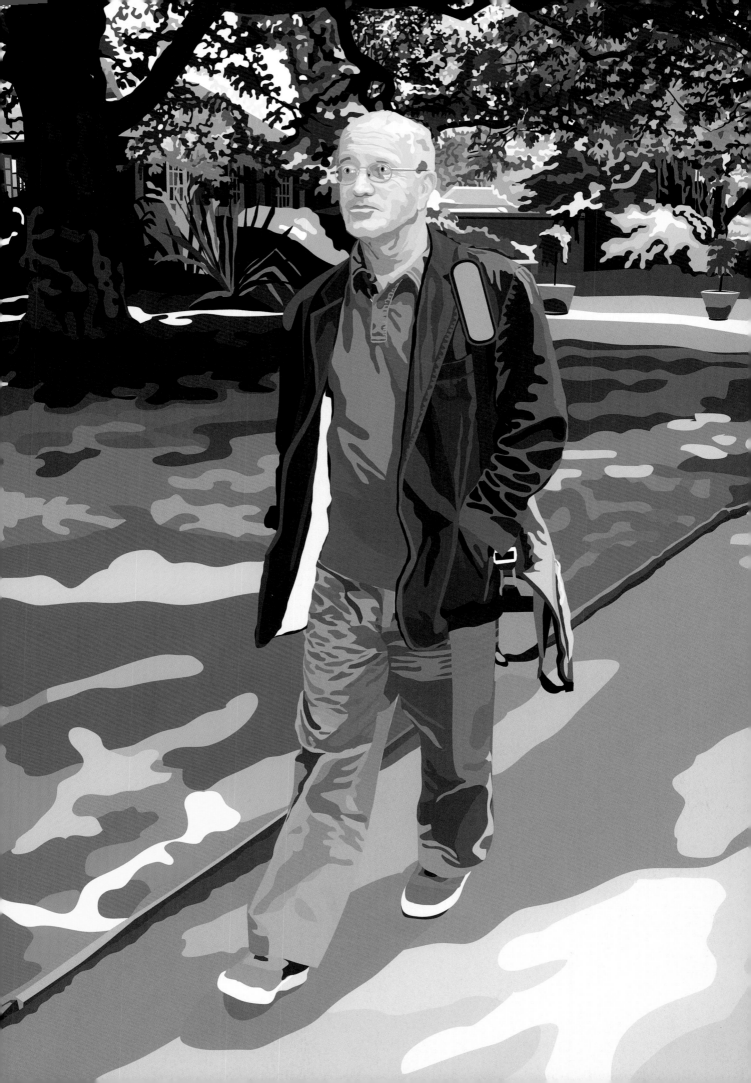

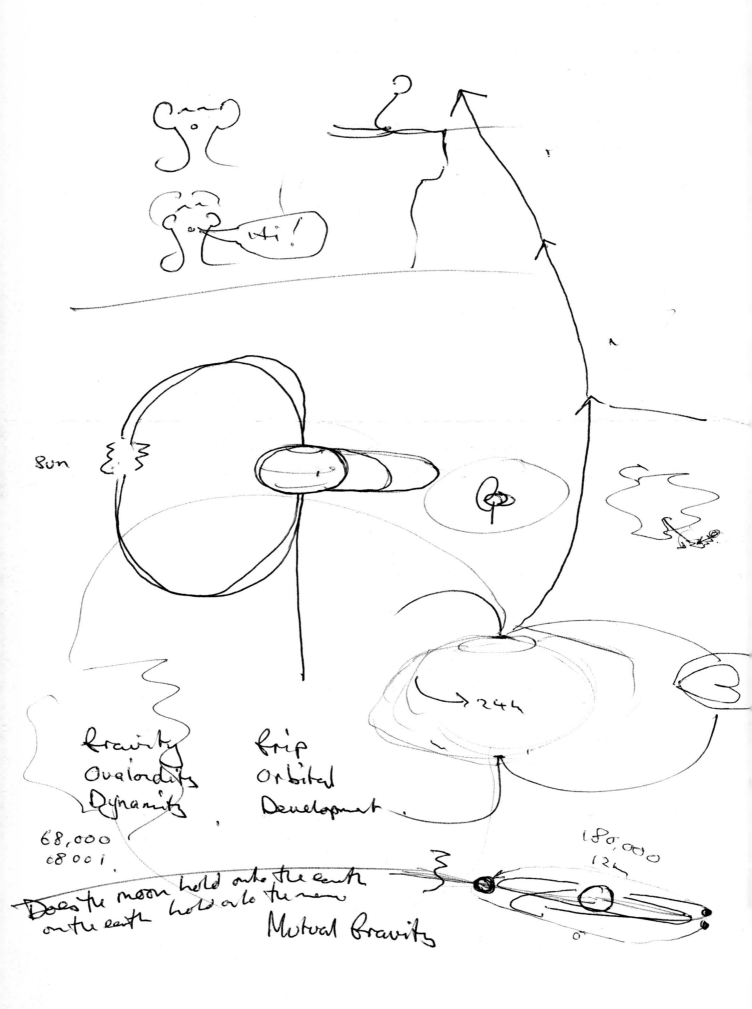

Sun

Gravity
Overcoming
Dynamity

frip
Orbital
Development.

68,000
08001.

180,000
12h

Does the moon hold onto the earth
on the earth hold onto the moon

Mutual Gravity

→24h

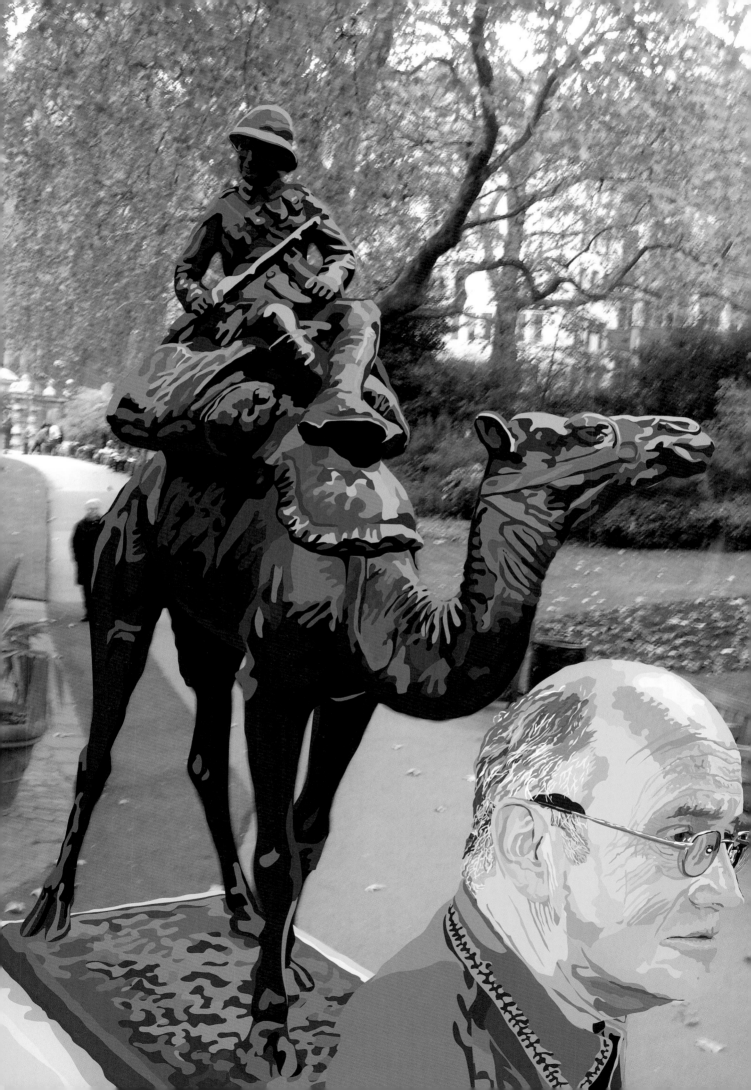

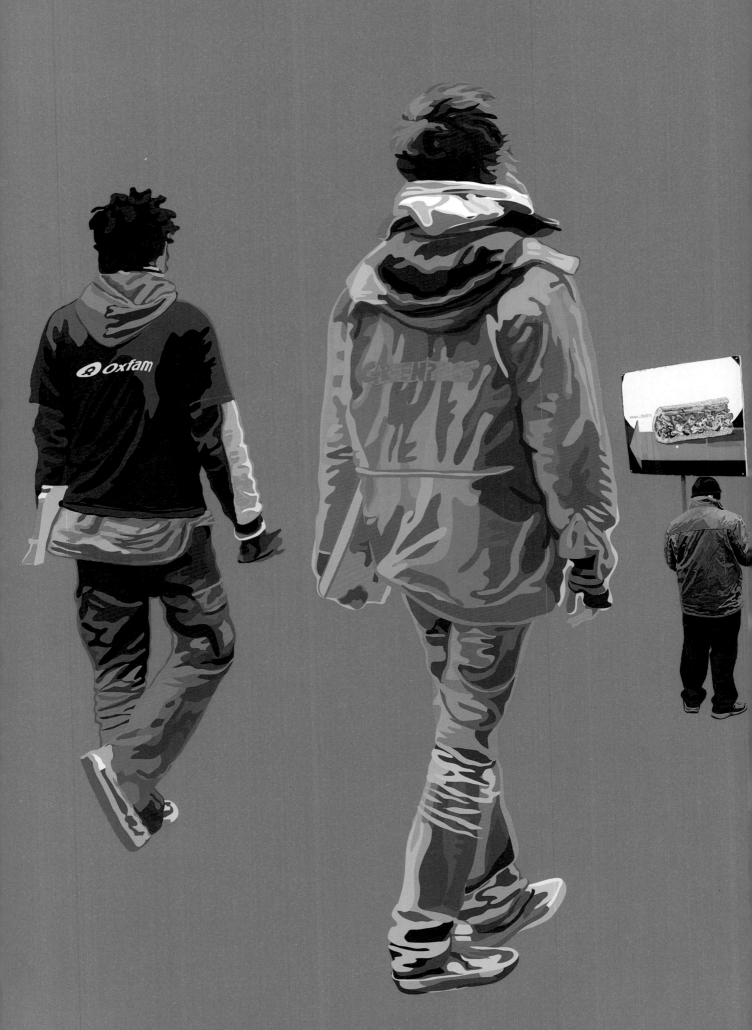

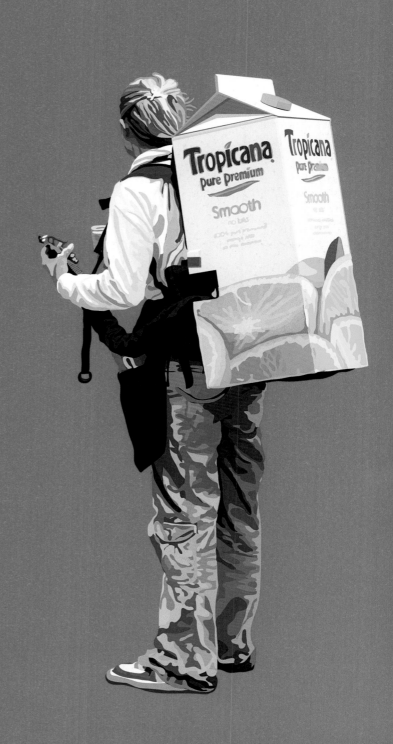

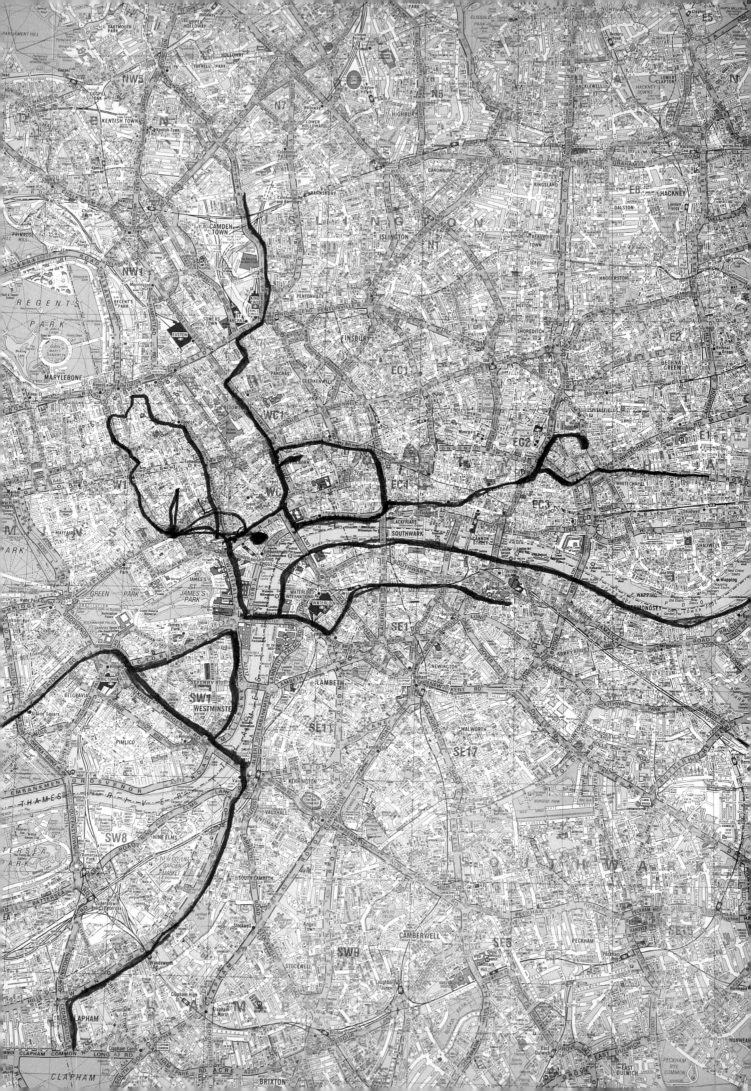

London (and who incidentally was involved with the 'One Tree Hill' disturbance – see Chapter 25).

The loafers were all around. Unemployed people slept rough on the Embankment, on London Bridge, in Covent Garden and most conspicuously in Trafalgar Square. Their presence was a horrible reminder of the seamier side of Victorian success (to reformers) and an emblem of moral turpitude and decline (to the authorities). Proposals were made to fence Trafalgar Square, which was now surrounded by the most prestigious buildings in London, and Queen Victoria was written to by Lord Salisbury to ask her approval – after all the Square was part of the Crown Estates. Warren, mindful of his officers turning a 'blind eye' to the homeless and also aware that the SDF were organizing them under the slogan 'Not Charity, But Work', decided to revoke marches by the poor who, with their red and black flags, smacked of 'an insurrectionary temper' which could not be allowed to continue. He also noted the poor seemed 'organised' and able to employ tactics to avoid arrest. There was clearly a secret conspiracy.

To meet this 'conspiracy', the force that he could call upon as Commissioner was quite different from the small, beleaguered and motley crew that had been the Bow Street Police. The Metropolitan Police District comprised an area up to fifteen miles in any direction from Charing Cross (nearly 700 square miles), excepting the City, which had its own police. It covered parts of Essex and Hertfordshire as well as Surrey and Kent and it covered all the area of the expanding boroughs. There were twenty-one land divisions plus a river force, using about 200 police stations, each headed by a superintendent. It was a complex bureaucratic machine that included officers dealing with finance and property administration, the detectives of the Criminal Investigations Division and the 'secret police' known as Special Branch, set up originally to work against the Fenian threat. The force, through the Commissioner, was answerable to the Home Secretary and thus to Parliament.

Throughout the nineteenth century the entire machine was steadily expanded. According to one estimate, in 1829 seven Acts of Parliament related to the duties of the Metropolitan Police; by 1861 there were seventy-five; between 1861 and 1868 'scarcely a session of Parliament' ended without further duties being added relating to 'the supervision . . . of a vast multitude of details of more or less importance' on 'an immense variety of . . . subjects'; between January

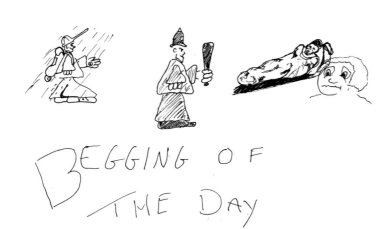

BEGGING OF THE DAY

Rob Wilson

0·600

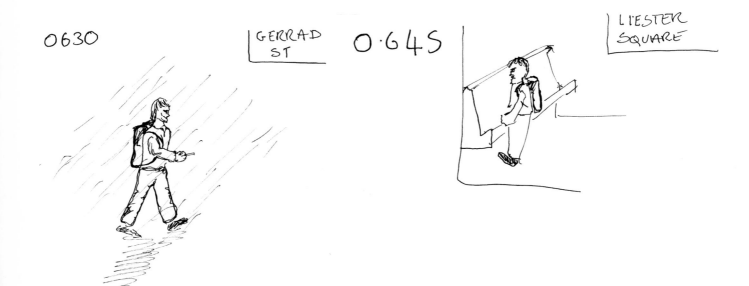

DEAN ST

0630 GERRAD ST 0·645 L'IESTER SQUARE

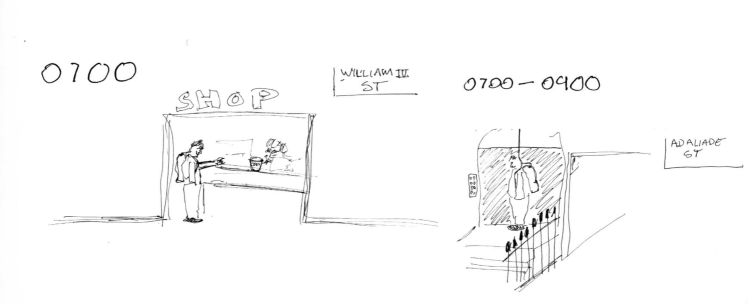

0700 SHOP WILLIAM IV ST 0700 – 0900 ADALIADE ST

0400 – 1300 The Connection 1300 – 1500

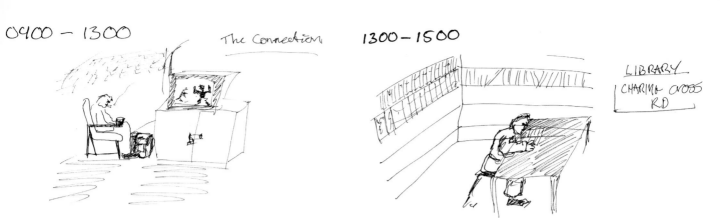

LIBRARY
CHARING CROSS
RD

Library & Learning Centre
University for the Creative Arts

1530 15·45 GERRARD
 ST

LESEISTER
SQ

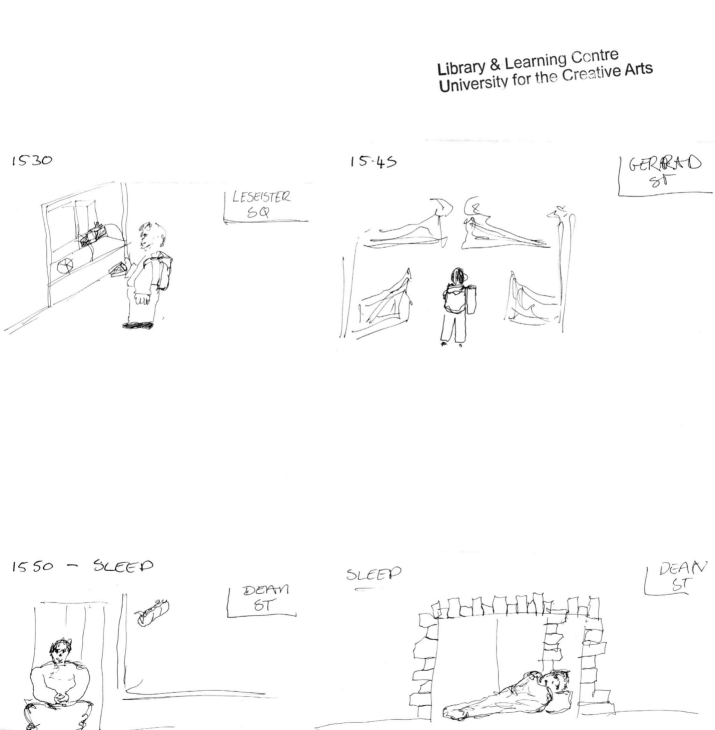

1550 – SLEEP DEAN SLEEP DEAN
 ST ST

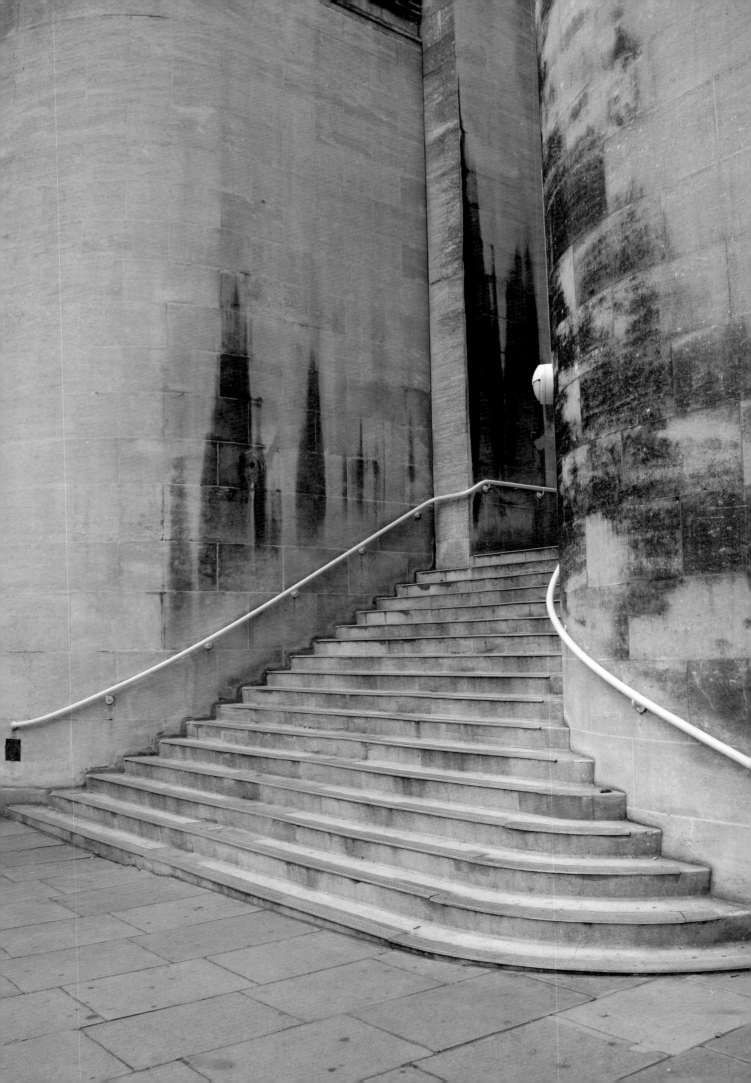

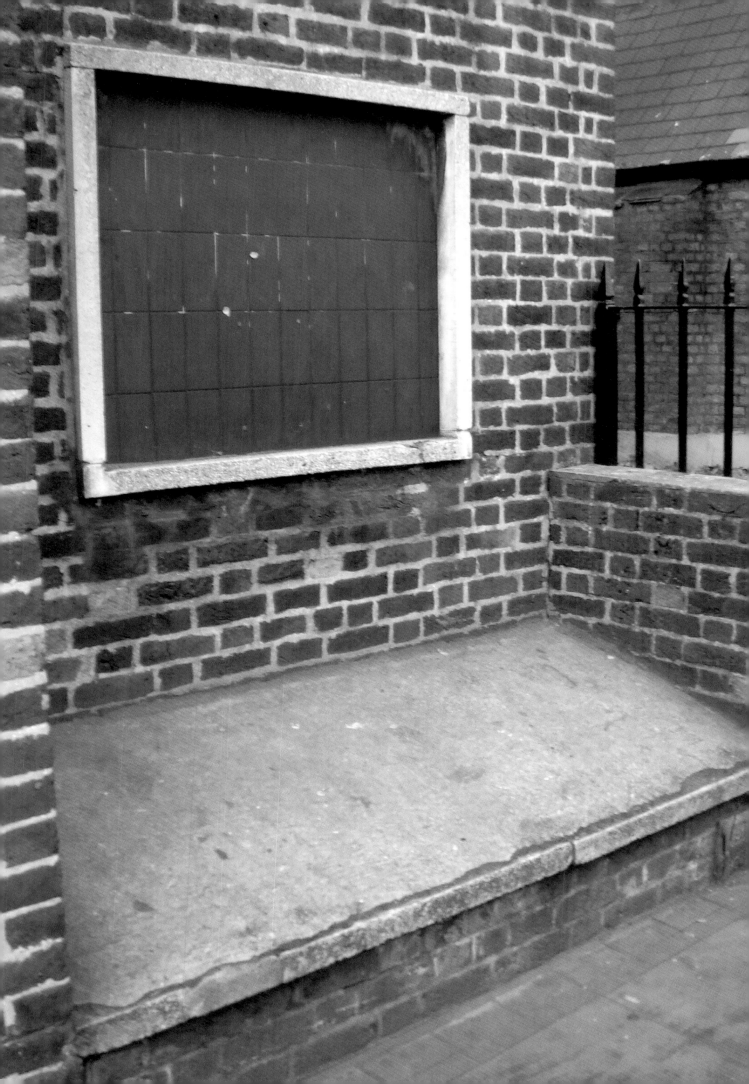

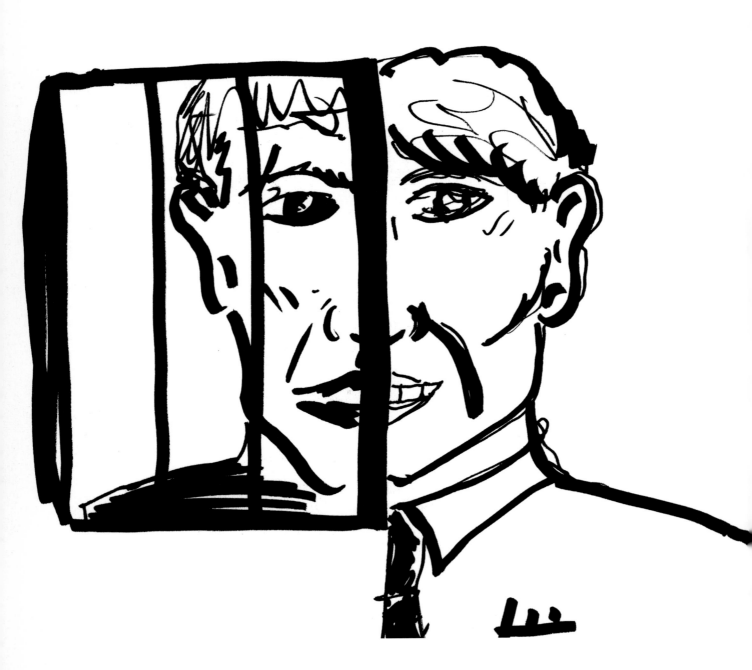

Terroir

Originally the term used to describe the differences that regionality bestows on a product such as wine, coffee and tea. Products that used to be generic (such as jeans and trainers) have, since the 1980s, become increasingly branded. One means of making globally distributed generic products more appealing and unique is the use of terroir as a strategy – branding everyday products (and eventually culture and artists) like special cheese and fine wines – regionally.

Tourist

A visitor from the UK or overseas, who is in the area for a holiday, to visit friends or relations, or for business, conferences or any other purpose, and who is not usually resident in the area.

Townscape

The ensemble of buildings, streets and spaces and their collective contribution to the character and appearance of an area.

Tree preservation order (TPO)

Trees are given special protection under the Town and Country Planning Act 1990. If a tree is protected by a TPO then it is an offence to top, lop or fell it without consent.

Urban design

The design of buildings, groups of buildings, spaces and landscapes in towns and cities and the establishment of policies, frameworks and processes that aim to facilitate successful development.

Urban grain/ Urban morphology

The arrangement, hierarchy and size of buildings, their plots in a settlement and their overall relationship to the distinctive layout of streets, squares and open spaces of a particular place.

Vagrancy

A term, now broadly seen as concurrent with 'homelessness', that has the added implication of begging. The term is now dated and in its original context, referred to a person who was homeless but fit enough to work but chose not to. Based on this definition, vagrancy was a crime in much of Europe up until the latter half of the twentieth century.

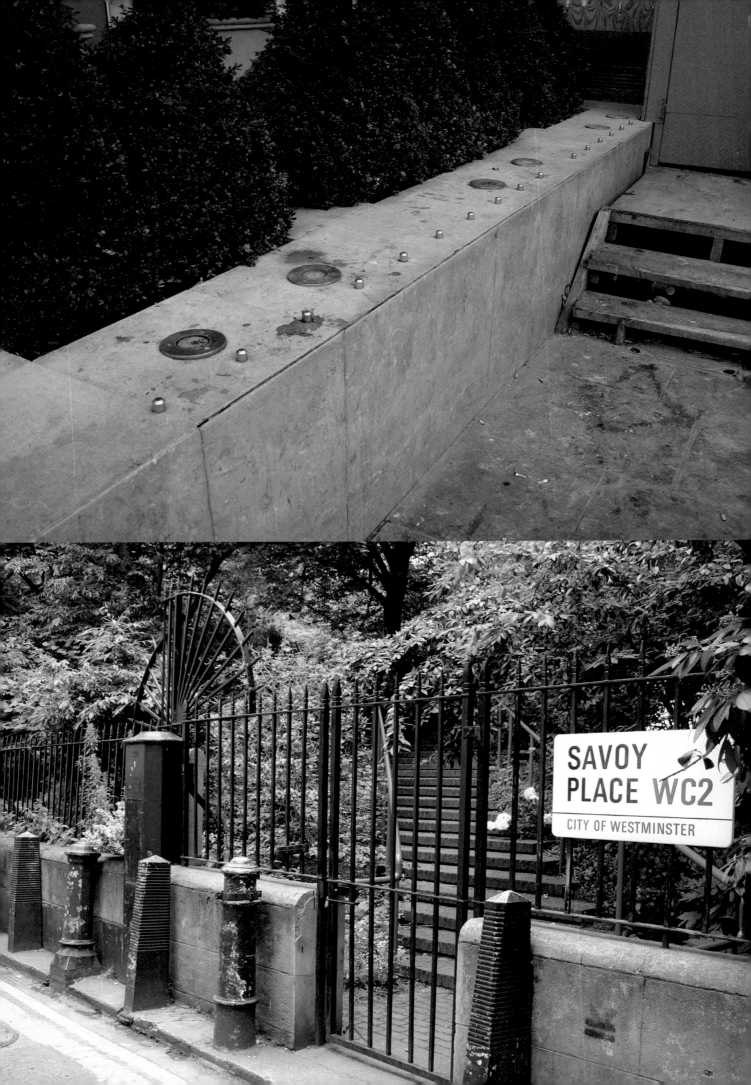

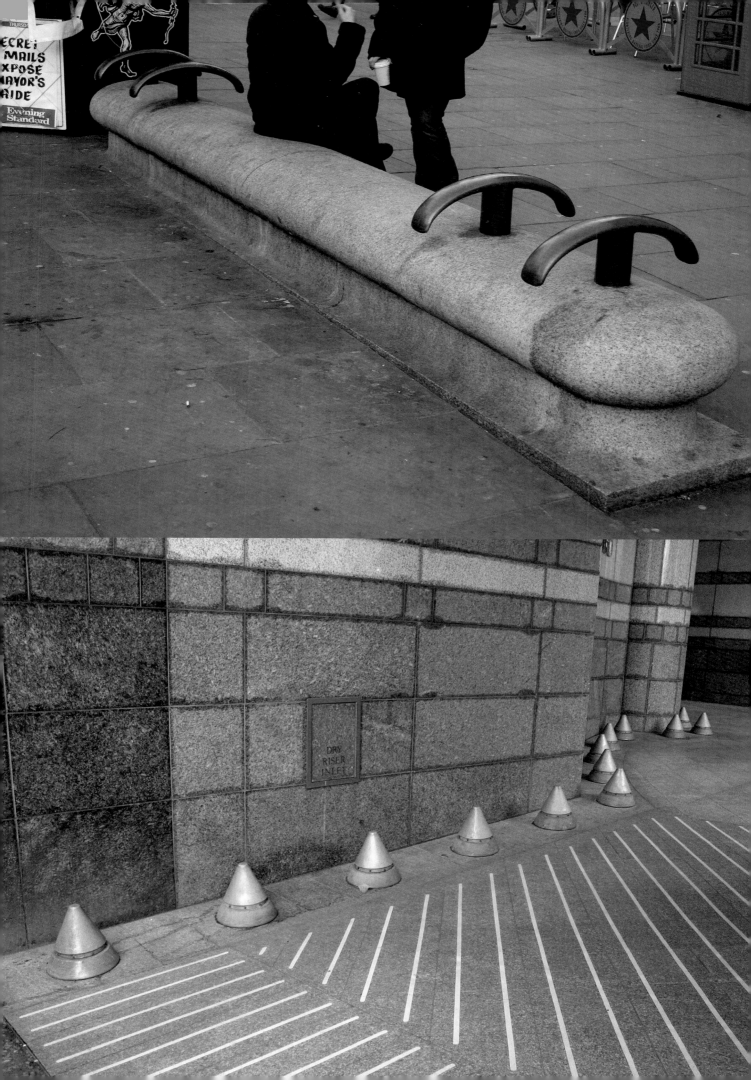

Vagabond

Originally a British legal term for a homeless person, similar to 'vagrant', that had the added connotation of a person as traveller. Like vagrancy, it was originally an offence in Britain. In the romanticism of the nineteenth century, the term came to have the positive connotation of a bohemian with a 'wandering spirit'.

Vernacular

The style of ordinary buildings built in a particular place, making use of local styles, techniques and materials and responding to local economic and social conditions, rather than to a specific architectural or design idea or movements.

Visitor

A person visiting an area in which they are not normally resident or where they do not normally work, often involving a visit to an attraction, for example, a theatre or a sporting event.

Vista

An enclosed view, usually a long narrow one.

Visual clutter

Uncoordinated arrangement and excessive amount of street furniture, signs, plants, air-conditioning equipment and/or other features which adversely affects the appearance of an area.

World city

A major city, widely recognised as a globally successful business location, when measured on a wide range of indicators such as financial services, government, business, higher education, culture and tourism. World-city status is possessed by only a small number of the world's cities, including New York, Tokyo and London.

Zero tolerance

The concept of giving carte blanche to the police for the inflexible repression of minor offences, homeless people and the disorders associated with them. Under a system of zero tolerance, persons in positions of authority – who might otherwise exercise their discretion in making subjective judgments regarding the severity of a given offense – are instead compelled to act in particular ways and, where relevant, to impose a pre-determined punishment regardless of individual culpability or 'extenuating circumstances'.

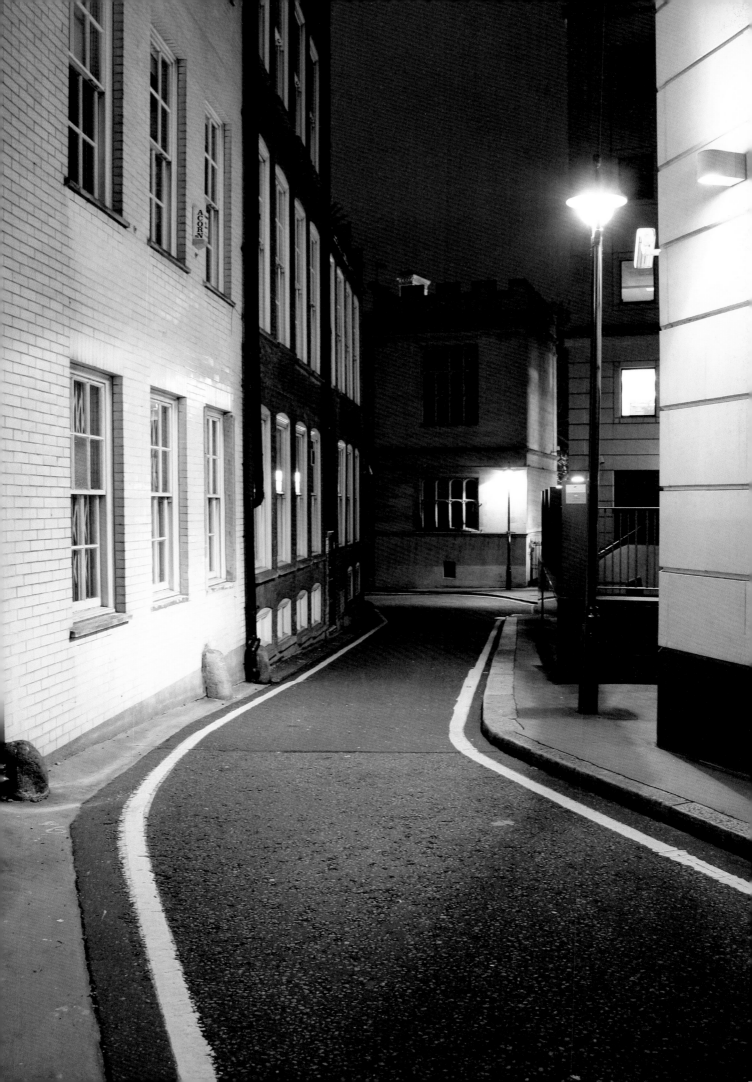

Legal and historical milestones in relation to homelessness and housing provision

1601 **The Old Poor Law, 'An Acte for the Reliefe of the Poore'**
Generally seen as the beginning of formalised provisions for the poor and homeless although there had been a number of earlier acts of which this was a refinement. The act distinguished between able-bodied and impotent poor. Help was made to find the able-bodied poor work, and if they refused, they were placed in a 'House of Correction'. Impotent poor were meant to be provided with a place of dwelling and responsibility for their maintenance fell on their immediate family. The parish was responsible for both collecting poor rates, and distributing them to those in need.

1662 **The Settlement Act, 'An Act for the better Relief of the Poor of this Kingdom'**
This act allowed the travelling poor to be sent back to their original parish if they were likely to need to claim relief under the poor law and therefore prohibited movement of the poor and homeless.

1722 **The Workhouse Test Act, 'For Amending the Laws relating to the Settlement, Imployment and Relief of the Poor'**
The act allowed parishes to set up workhouses in which the destitute could work and live. The prospect was also meant to be a deterrent to the able-bodied poor and only take those in who were desperate enough to accept its hard regime.

1832 **The Royal Poor Law Commission was appointed**

1834 **Poor Law Amendment Act**
Reworking of the organisation of poor relief and more standardised treatment throughout the country as prior systems did not seem to be working. Giving relief to the able-bodied poor was declared unlawful in an attempt to stop dependency on relief.

1905 **The 1905 Royal Commission**
Among its differing recommendations was the complete abolition of the poor laws and an emphasis on preventing destitution rather than providing relief. Old age pensions and national insurance were introduced as a result of this commission.

1911 **Smash Up the Workhouse**
George Lansbury's influential and provactive pamphlet argued that few people needed to be in the workhouse, especially those who were able-bodied and for those with no other option, the workhouse regime should be softened.

1942 **Beveridge Report**
Proposed system of National Insurance based on the assumptions of: family allowances, a national health service and full employment.

1966 *Cathy Come Home* **screened on BBC**
Appalling tale of Cathy and her family brings hidden housing crisis to light. Outraged viewing public demands an end to slums. The charity Shelter is founded.

1971 More than 2,500 children end up in care as a result of homelessness. The rent act is passed.

1976 Nearly 34,000 households accepted as homeless in England; double the number in 1971. More than 15,000 substandard hostel places used each night.

1980 Housing Act introduces Right to Buy for council tenants and a new shorthold tenure for the private rented sector.

1982 Introduction of Housing Benefit, which suffers cuts in subsequent budgets, replaces rent rebate and supplementary benefit.

1986 Shelter helps overturn House of Lords judgement that rehousing homeless people in temporary accommodation is sufficient.

1988 Housing Act introduces financial and legal changes that mean housing associations will become biggest providers of social housing.

1990 Shelter and Citizens Advice Bureau launch National Homelessness Advice Service. Government announces the rough sleeper initiative to tackle street homelessness.

1992 Local authorities accept 141,860 households as being homeless in England. This represents around 407,000 men, women and children.

1996 Housing Act erodes some of the rights of homeless people enshrined in the 1977 Act.

2002 Homelessness Act strengthened the legal safety net for more people facing homelessness.

2003 Homelessness etc Act (Scotland) passed, pledging that everyone who is homeless in Scotland will have a home by 2012.

2004 Strict limits to the time families can spend in bed and breakfast accommodation introduced. Government announces target to halve temporary accommodation by 2012. Housing Act contains new legislation updating overcrowding standards, protecting tenants' deposits, improving rights for travellers and gypsies, and reforming Right to Buy.

2005 House of Lords ruling that government is wrong to deny asylum seekers support welcomed by Shelter as human-rights victory. Housing Act (Scotland) 2005 passed.

Pattern. Anonymous 2006
© The artist 2008

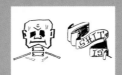

Drawings. Robert Wilson 2006
© Robert Wilson 2008

Diagram. Anonymous 2006
© The artist 2008

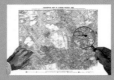

Drawing of Charles Booth's 'poverty map' 1889. This map described, in detail, the social condition of the residents of London at the time and helped lead to greater government intervention against the poverty in the early 20th century.
Map redrawn from Charles Booth's *Descriptive Map of London Poverty* 1889, published by the London Topographical Society in 1984. Magnifying glass map is reproduced by permission of Geographers' A-Z Map Co Ltd. © Crown Copyright 2008. All rights reserved. Licence number 100017302.
Digital drawing. Nils Norman 2007

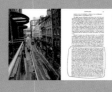

View of Villiers Street, Charing Cross. Digital drawing. Nils Norman 2007

Extract from *Violent London*, Clive Bloom and Pan Macmillan, London.
© Clive Bloom 2008

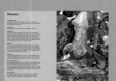

Glossary terms and definitions taken from a variety of sources including Wikipedia, publications by Neil Smith, David Harvey, Doreen Massey and others. Extracts from *Westminster City Council's Unitary Development Plan* with permission of Westminster City Council.

Derived from detail of Maggi Hambling's *A Conversation with Oscar Wilde* 1998.
Digital drawing. Nils Norman 2007

Drawing. Anonymous 2006
© The artist 2008

Alan Moore walking across a map drawn on by an anonymous user of The Connection at St Martin's. Gargoyles, aquatic creatures and bird representations found along the Victoria Embankment and nearby streets. Map reproduced by permission of Geographers' A-Z Map Co Ltd. © Crown Copyright 2008. All rights reserved. Licence number 100017302.
Digital drawing. Nils Norman 2007

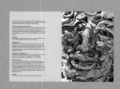

Detail of Maggi Hambling's *A Conversation with Oscar Wilde* 1998.
Digital drawing. Nils Norman 2007

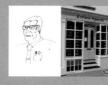

Drawing. Robert Wilson 2006
© Robert Wilson 2008

Estate agents Rose St, WC1.
Digital drawing. Nils Norman 2007

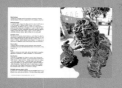

Maggi Hambling's sculpture sits outside The Connection at St Martin-in-the-Field and is familiar to the centre's staff and clients.
Digital drawing. Nils Norman 2007

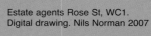

Estate agents Rose St, WC1. Engravings by Gustave Doré.
Digital drawing. Nils Norman 2007

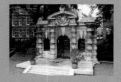

The water gate in Victoria Embankment Gardens was built in 1626 as the entry to the Thames for York House, which became the Duke of Buckingham's residence. The water gate remains in its original position, however it is now 100m from the embankment of the Thames.
Photograph. Nils Norman 2007

Drawing. Robert Wilson 2006
© Robert Wilson 2008

Victoria Embankment area.
Photographs. Nils Norman 2008

Stairs, Victoria Embankment.
Photograph. Nils Norman 2007

Diagram. Anonymous 2006
© The artist 2008

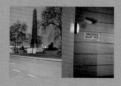

Victoria Embankment area.
Photographs. Nils Norman 2008

Diagram. Anonymous 2006
© The artist 2008

Bum-free surface, Victoria Embankment.
Photograph. Nils Norman 2008

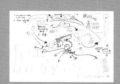

Drawing. A Stuart Perkins 2006
© A Stuart Perkins 2008

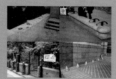

Drawing. Robert Wilson 2006
© Robert Wilson 2008

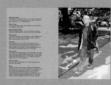

Iain Sinclair, Victoria Embankment Gardens.
Digital drawing. Nils Norman 2007

Various protective and defensive designs,
Embankment area.
Photograph. Nils Norman 2007

Diagram. Anonymous 2006
© The artist 2008

Iain Sinclair, Victoria Embankment Gardens
Digital drawing. Nils Norman 2007

Victoria Embankment area.
Photograph. Nils Norman 2007

'A pestilence on the city' Iain Sinclair and
various 'chuggers' (charity muggers) and
sandwich board men.
Digital drawing. Nils Norman 2007

Timeline of legal and historical milestones
in relation to homelessness and housing
provision since 1601. Extracts from *Shelter:
40 Years On* 2006. Reproduced with
permission from Shelter.

Library & Learning Centre
University for the Creative Arts

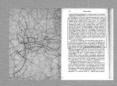

A traced map of various routes around central
London where free food and shelter can be
obtained. Anonymous 2006. Map reproduced
by permission of Geographers' A-Z Map Co
Ltd. © Crown Copyright 2008. All rights
reserved. Licence number 100017302.
Nils Norman 2007

Extract from *Violent London*, Clive Bloom
and Pan Macmillan, London.
© Clive Bloom 2008

Drawing. Robert Wilson, *Sun up 2
Moonlight* 2006
© Robert Wilson 2008

Trustees of the Serpentine Gallery
Lord Palumbo Chairman
Felicity Waley-Cohen and
Barry Townsley Co-Vice
Chairmen
Marcus Boyle Treasurer
Patricia Bickers
Roger Bramble
Marco Compagnoni
David Fletcher
Bonnie Greer
Zaha Hadid
Rob Hersov
Isaac Julien
Joan Smith
Colin Tweedy

Council of the Serpentine Gallery
Rob Hersov Chairman
Shaikha Paula Al-Sabah
Marlon Abela
Saffron Aldridge
Goga Ashkenazi
Mr and Mrs Harry Blain
Len Blavatnik
Alessandro Cajrati Crivelli
Jeanne and William Callanan
Ricki Gail Conway
Aud and Paolo Cuniberti
Carolyn Dailey
Guy and Andrea Dellal
Marie Douglas-David
Charles Dunstone
Jenifer and Mark Evans
Lorenzo Grabau
Elizabeth von Guttman
Richard and Odile Grogan
Mala and Oliver Haarmann
Jennifer and Matthew Harris
Petra and Darko Horvat
Michael Jacobson
Diana and Roger Jenkins
Dakis Joannou
Jimmy and Becky Mayer
Pia-Christina Miller
Martin and Amanda Newson
J. Harald Örneberg
Catherine and Franck
Petitgas
Eva Rausing
Yvonne Rieber
Spas and Diliana Roussev
Robin Saunders and
Matthew Roeser
Silvio and Monica Scaglia
Anders and Yukiko
Schroeder
Olivia Schuler-Voith
Nadja Swarovski
Robert and Felicity Waley-
Cohen
Bruno Wang
John and Amelia Winter
Manuela and Iwan Wirth
Cynthia Wu
Anna and Michael Zaoui
**And members of the
Council who wish to
remain anonymous**

**Council's Circle of the
Serpentine Gallery**
Ivor Braka
Nicholas Candy
Johan Eliasch
Michael and Ali Hue-Williams
Jolana Leinson and Petri
Vainio
Elena Marano
Matthew Mellon, in memory
of Isabella Blow
Tamara Mellon
Stephen and Yana Peel

**Founding Corporate
Benefactor**
Bloomberg

**Platinum Corporate
Benefactors**
Arup
Bovis Lend Lease Limited
Stanhope Plc
Swarovski
Zumtobel

**Gold Corporate
Benefactors**
Clipfine
Davis Langdon LLP
DP9
Keltbray
Laurent-Perrier
Puma
The Guardian
The Observer
Weil, Gotshal & Manges

**Silver Corporate
Benefactors**
Glitnir Bank
Samsung
Sotheby's
T. Clarke
Working Title

**Bronze Corporate
Benefactors**
agnès b
Barr Construction
The Bradley Collection
Carey Group Plc
Davis Langdon Schumann
Smith
Dewey Ballantine LLP
Elephant beanbags
EMS
Gardner & Co
GaydarNation.com
GTL Partnership
John Doyle Group
Konzept:werk
Kvadrat
Nüssli
The Pavement
Protec
Select Plant Hire Co Ltd
SES
Simmons & Simmons
Siteco
Swift Horsman Limited
Vector Foiltec
William Hare Ltd

**Education Projects
supported by**
Bloomberg

**Education Programme
supported by**
The Annenberg Foundation
Awards for All
Big Lottery Fund
City Bridge Trust
Eranda Foundation
Fondation de France
Grants for the arts
Heritage Lottery Fund
Housing Corporation
JJ Charitable Trust
John Lyon's Charity
London Councils

Netherlands Architecture
Fund
Royal Commission for the
Exhibition of 1851
Foundation
Royal Norwegian Embassy
The Dr Mortimer and
Theresa
Sackler Foundation

And kind assistance from
Embassy of Denmark,
London
The Lone Pine Foundation
The Nyda and Oliver Prenn
Foundation
The Office for Contemporary
Art Norway
The Royal Borough of
Kensington and Chelsea
Westminster Arts
Westminster City Council

Exhibition Programme
supported by
303 Gallery, New York/Lisa
Spellman
Cristina Bechtler/ Inktree,
Switzerland
Burger Collection
Switzerland/
Hong Kong
Cao Fei and Lombard-Freid
Projects
Calouste Gulbenkian
Foundation
Center for Icelandic Art,
Iceland
Frank and Cherryl Cohen
Sadie Coles/Sadie Coles HQ
Contemporary Fine Arts,
Berlin
Marie Donnelly
Embassy of the United
States of America, London
Fondation Cartier pour l'art
contemporain
Larry Gagosian/Gagosian
Gallery
Greene Naftali Gallery, New
York
Pia-Christina Miller
Galerie Urs Meile, Lucerne-
Beijing
The Henry Moore
Foundation
Maja Hoffmann, LUMA
Foundation
Pierre Huber
Jay Jopling/White Cube
John Kaldor and Naomi
Milgrom
Sean and Mary Kelly, New
York
Lazarides Gallery
Mr and Mrs Edward Lee
Aaron and Barbara Levine
Toby Devan Lewis
The Linbury Trust
Matthew Marks Gallery
Ministry of Education,
Science and Culture, Iceland
Ministry for Foreign Affairs,
Iceland
Victoria Miro Gallery
Outset Contemporary Art
Fund
Parkview International
London PLC
John and Amy Phelen
The Red Mansion
Foundation
Mrs Turidur Reynisdottir
Craig Robins
Ruth and Richard Rogers
Royal Netherlands Embassy
Royal Norwegian Embassy
Novator Partners LLP
Sigurõur Gísli Pálmason
Galerie Eva Presenhuber,
Zürich/ Eva Presenhuber
Esther Schipper

Melissa and Robert Soros
Galerie Sprüth Magers,
Cologne, Munich/Monika
Sprüth and Philomene
Magers
Julia Stoschek Foundation
e.V.
David Tang
David Teiger
Guy and Myriam Ullens
Foundation

Emeritus Benefactor
Edwin C Cohen and
The Blessing Way
Foundation

Honorary Patron
Anthony Podesta, Podesta/
Mattoon.com, Washington
DC

Honorary Benefactors
Gavin Aldred
Mark and Lauren Booth
Noam and Geraldine
Gottesman
Mark Hix
Catherine and Pierre
Lagrange
Stig Larsen
George and Angie Loudon
Jo and Raffy Manoukian
Des McDonald

Patrons
Abstract Select Ltd
Mrs Sigi Aiken
Marie-Claire Baroness von
Alvensleben
Mr Christian Angermayer
Dr Bettina Bahlsen
Simon Bakewell and Cheri
Phillips
BBH
Steve and Carrie Belotti
Philippe and Bettina
Bonnefoy
Frances Bowes
Brian Boylan
Basia and Richard Briggs
Mrs Rita Caltagirone
Laurent and Micky Caraffa
Mr and Mrs Federico Ceretti
Rattan Chadha
Patricia Chi and Domenico
Azzollini
Dr Martin A Clarke
Sir Ronald and Lady Cohen
Terence and Niki Cole
Stevie Congdon and Harriet
Hastings
Alastair Cookson
Rob and Siri Cope
Alex Dann
Kimbell and Yelena Duncan
Frank and Lorna Dunphy
The Edwin Fox Foundation
Mrs Carmen Engelhorn
Leonardo and Alessia
Giangreco
Karine Giannamore
Chris and Jacqui Goekjian
David Gorton
Sir Ronald Grierson
Reade and Elizabeth Griffith
Mr and Mrs Habib
Philip Hoffman - The Fine Art
Fund
Marianne Holtermann and
Lance Entwistle
Dorian Jabri
Tim Jefferies
Dr Morana Jovan and Mr
George
Embiricos
Mr and Mrs Karim Juma
Pauline Karpidas
Eddie and Danny Lawson
Mr Edouard Lecieux
Mr and Mrs Simon Lee
Rachel Lehmann and David

Maupin
Peder Lund
Aniz Manji
Mrs Alexandrina Markvo
Andrew and Jacqueline
Martin
Vincent and Elizabeth Meyer
Mr Donald Moore
Emilia Mosseri
Gregor Muir
Paul and Alison Myners
Yuki Oshima-Wilpon
Cornelia Pallavicini
Katherine Priestley and
David Pitblado
Ivan and Marina Ritossa
Hugo Rittson-Thomas
Kadee Robbins
David Roberts
Lily Safra
The Selvaag Family
Alan and Joan Smith
Lord Edward Spencer-
Churchill
Mr and Mrs David Stevenson
Siri Stolt-Nielsen
Ian and Mercedes Stoutzker
Laura and Barry Townsley
Melissa Ulfane
Dr Vera Vucelic
Peter Wheeler and Pascale
Revert
Benedict Wilkinson and Mia
Spence
Mr Samer Younis and Mrs
Rana Sadik
Poju and Anita Zabludowicz
Riccardo Zacconi

**Future Contemporaries
Committee**
Tim Franks
Liz Kabler
Dan Macmillan
Bobby Molavi
Jake Parkinson-Smith
Cristina Revert
Stan Stalnaker
Christopher Taylor
Marcus Waley-Cohen
Jonathan Wood

Members
Alia Al-Senussi
The A Team Foundation
Laura Bartlett
The Hon. Alexander Brennan
James and Felicia
Brocklebank
William Burlington
Mr and Mrs Gauray Burman
Damian Byrnes
Samir Ceric, Salon Gallery
Lucy Chadwick
Cristina Colomar
Tamara Corm and Saadi
Soudavar
Conor Cunningham and Julie
Delylle
Dahlia Dana
Anna Dickie
Marie Estienne
Sophie Eynon
Flora Fairbairn
Moritz Fried
Patrick Gibson
Philip Godsal
Rebecca Guinness
Guy and Alexandra Halamish
Colin M Hall
Edward Hanson
Camilla Johnson-Hill
Nicholas W. Hofgren
Jeff Holland
Olivia Howell and Michael
Patterson
Amber Hsu
Robin Katz Fine Art
KAZ
Leila Khazaneh
Jessica Kimmel
Jack Kirkland

Marina Kissam
Katherine Knox and James
Harvey
Alexa Jeanne Kusber
Arianne Levene
Jason Lee
James Lindon
S.P Machin and F.G Calder
James Maizels
Marina Marini
Fernando J. Moncho Lobo
James Morse
Joanna Needham
Sheryl Needham
Isabelle Nowak and Torsten
Winkler
Karim Palmieri
Samira Parkinson-Smith
Andrew Pirrie
Harry Plotnick
Robert Ramsauer
Laurent Rappaport
Rebecca Richwhite
David Risley Gallery
Nick Rose
Miss Naiki Rossell Pérez
Correa
Melanie Salmon
Candi Schemann
Sudhanshu Swaroop
Mieka Sywak
Jérémie Vaislic
Lucy Wood
Fabrizio D. Zappaterra

Benefactors
Heinz and Simone
Ackermans
Mishari Al-Bader
Mr Niklas Antman and Miss
Lisa Almen
Paul and Kia Armstrong
Max Alexander and Anna
Bateson
Archeus
Mrs Bernard Asher
Ian and Charlotte Artus
Pedro C de Azambuja
Laurie Benson
Anne Best and Roddy
Kinhead-Weekes
Roger and Beverley Bevan
Lavinia Calza Beveridge
David and Janice Blackburn
Anthony and Gisela Bloom
Mr and Mrs John Botts
Marcus Boyle
Vanessa Branson
Michael and Pauline
Brennan
Dick and Paulette Brittain
Mrs Conchita Broomfield
Benjamin Brown
Mr and Mrs Charles Brown
Ossi and Paul Burger
John and Susan Burns
Mr and Mrs Philip Byrne
Jonathan and Vanessa
Cameron
Andrew Cecil
Monkey Chambers
Zia Chatila
Shirin Christoffersen
Mr Giuseppe and the late
Mrs Alexandra Ciardi
Mr and Mrs David Cohen
Louise-Anne Comeau
Carole and Neville Conrad
Alexander Corcoran
Ilar Corrias and Adam
Prideaux
Ful Coskun
Dan Curci
Linda and Ronald F Daitz
Jasmine Datnow
Helen and Colin David
Paul Davies
Lynne Dec and Andrea Prat
Robin and Noelle Doumar
Neil Duckworth
Randolph and Denise

Dumas
Adrienne Dumas
Jessica Dunne and Brian
Reshefsky
Mike Fairbrass
Mr and Mrs Mark Fenwick
Stephanie Ferrario
John Ferreira
Ruth Finch
Hako and Dorte Graf von
Finckenstein
Harry and Ruth Fitzgibbons
David and Jane Fletcher
Bruce and Janet Flohr
Robert Forrest
Eric and Louise Franck
Honor Fraser
James Freedman and Anna
Kissin
Lady Deedam Gaborit
Tatiana Gertik
Zak and Candida Gertler
Hugh Gibson
David Gill
Mr and Mrs John Gordon
Dimitri J Goulandris
Francesco Grana and
Simona Fantinelli
Linda and Richard Grosse
The Bryan Guinness
Charitable Trust
Philip Gumuchdjian
Sascha Hackel and Marcus
Bury
Abel G Halpern and Helen
Chung-Halpern
Roderick and Jenny Hall
Louise Hallett
Mr and Mrs Antony Harbour
Susan Harris
Maria and Stratis
Hatzistefanis
Mr and Mrs Rick Hayward
Thomas Healy and Fred
Hochberg
Alison Henry
Michael and Sarah Hewett
Mrs Samantha Heyworth
Mrs Juliette Hopkins
Mrs Martha Hummer-Bradley
Montague Hurst Charitable
Trust
Mr Michael and Lady
Miranda Hutchinson
Iraj and Eva Ispahani
Nicola Jacobs and Tony
Schlesinger
Mrs Christine Johnston
Susie Jubb
Howard and Linda Karshan
Jennifer Kersis
Malcolm King
James and Clare Kirkman
Tim and Dominique Kirkman
Mr and Mrs Charles Kirwan-
Taylor
Herbert and Sybil Kretzmer
Mr and Mrs Lahoud
Britt Lintner
Barbara Lloyd and Judy
Collins
Sotiris TF Lyritzis
Steve and Fran Magee
Mr Otto Julius Maier and Mrs
Michèle Claudel-Maier
Claude Mandel and Maggie
Mechlinski
Cary J Martin
Cat Martin
Mrs Patricia Masri-Ephrati
Mr and Mrs Stephen Mather
Viviane and James Mayor
Alexandra Meyers
Warren and Victoria Miro
Susan and Claus
Moehlmann
Jen Moores
Gillian Mosely
Richard Nagy and Caroline
Schmidt
Andrei Navrozov
Angela Nikolakopoulou

Dalit Nuttall
Georgia Oetker
Sandra and Stephan Olajide
Tamiko Onozawa
Mr and Mrs Nicholas
Oppenheim
Linda Pace
Desmond Page and Asun
Gelardin
Maureen Paley
Dominic Palfreyman
Midge and Simon Palley
Kathrine Palmer
Andrew and Jane Partridge
Julia Peyton-Jones OBE
George and Carolyn Pincus
Lauren Papadopoulos
Prakke
Victoria Preston
Sophie Price
Mathew Prichard
Ashraf Qizilbash
Max Reed
Michael Rich
John and Jill Ritblat
Bruce and Shadi Ritchie
Kasia Robinski
Kimberley Robson-Ortiz
Foundation
Jacqueline and Nicholas Roe
Victoria, Lady de Rothschild
James Roundell and Bona
Montagu
Rolf and Maryam Sachs
Nigel and Annette Sacks
Michael and Julia Samuel
Ronnie and Vidal Sassoon
Joana and Henrik
Schliemann
Glenn Scott Wright
Nick Simou and Julie
Gatland
Mr and Mrs Jean-Marc
Spitalier
Bina and Philippe von
Stauffenberg
Tanya and David Steyn
Simone and Robert Suss
Emma Tennant and Tim
Owens
The Thames Wharf Charity
Christian and Sarah von
Thun-Hohenstein
Britt Tidelius
Suzanne Togna
Emily Tsingou
JP Ujobai
Ashley and Lisa Unwin
David and Emma Verey
Darren J Walker
Audrey Wallrock
Offer Waterman
Rajan and Wanda Watumull
Daniel and Cecilia Weiner
Alannah Weston
Helen Ytuarte White
Robin Wight and Anastasia
Alexander
Martha and David Winfield
Mr. Ulf Wissen
Mr and Mrs M Wolridge
Chad Wollen and Sian
Davies
Nabil N Zaouk
Andrzej and Jill Zarzycki

**And Patrons, Future
Contemporaries and
Benefactors who wish to
remain anonymous**

Serpentine Gallery Staff

**Director, Serpentine Gallery
and Co-Director, Exhibitions
and Programmes**
Julia Peyton-Jones

**Co-Director, Exhibitions
and Programmes and
Director of International
Projects**
Hans Ulrich Obrist

**Executive Assistant to
Julia Peyton-Jones**
Cherie Fullerton

**Executive Assistant
to Hans Ulrich Obrist**
Lorraine Two

Head of Finance
Fern Stoner

Senior Finance Officer
Nina Yao

Finance Officer
Constance Odeyemi

HR Manager
Rachel Seghers

Head of Development
Louise McKinney

**Senior Corporate
Development Manager**
Catherine Lennkh

Head of Grants
Antoinette O'Loughlin

Events Organiser
Judith Carlton

Development Manager
Elli Loizou

Development Officer
Claire Flannery

**Development
Administrator**
Emily Gardener

Head of Press
Rose Dempsey

Press & Publicity Manager
Tom Coupe

Press Assistant
Varind Ramful

**Print and Publications
Manager**
Ben Fergusson

Prints Manager
Debbie Bullen

Head of Programmes
Sally Tallant

Education Organiser
Eleanor Farrington

Project Organiser
Louise Coysh

**Public Programmes
Organiser**
Emma Ridgway

Inspire Fellow
Eva McGovern

Exhibition Curator
Kathryn Rattee

Exhibition Curator
Rebecca Morrill

Gallery Manager
Michael Gaughan

**Assistant to Gallery
Manager**
Darran Armstrong

Exhibition Assistant
Leila Hasham

**Head of Building and
Operations**
Julie Burnell

Facilities Manager
Mark Songui

**Assistant to Head of
Buildings and Operations**
Sarah Diggins

Duty Managers
Kate Sinclair
Stuart Humpage

Gallery Assistants
Jayne Archard
Florence Boyd
Olle Borgar
Louisa Chambers
Craig Cooper
Paul Daulby
Jack Hardwick
Joel Hjort
Andrew Johnson
Magnus Jorde
Sasha Kachur
Benison Kilby
Jennifer Lapsley
Elysa Lozano
Donna Marris
Robert Nicol
Rachel Ninis
Virginia Phongsathorn
Anna Pickering
Will Potter
Rajesh Punj
Kathy Shenoy
Rene Songui
Arthur Steward
Ed Suckling
Gavin Ramsey
Edwin Rostron
Gabriel Tejada
Dan Walwin

Nils Norman would like to thank
Everyone at The Connection at St Martin's with whom he met and worked with, especially Kevin Knight, Wyn Newman and Robert Wilson. All the people kind enough to be interviewed: John Bird, Paul Chatterton, Rosalyn Deutsche, David Harvey, Doreen Massey, Alan Moore, Iain Sinclair, Neil Smith and Sharon Zukin. Also thanks to Sarina Basta, Mariana Cánepa Luna, Lucie Ewin, Eva and Roger Heyes, Gareth James, Mike Moorcroft, Emily Pethick, Emma Ridgway and Keith Sargent. With special thanks to Louise Coysh, Susan Eskdale and Sally Tallant.

Charing Cross by Nils Norman

Commissioned by the Serpentine Gallery, London

Julia Peyton-Jones, Director, Serpentine Gallery and Co-Director, Exhibitions and Programmes

Hans Ulrich Obrist, Co-Director, Exhibitions and Programmes and Director of International Projects

Sally Tallant, Head of Programmes

Louise Coysh, Project Organiser

Edited by Louise Coysh
Copy edited by Lucie Ewin, Rook Books and Ben Fergusson
Designed by Keith Sargent, immprint ltd, London
Printed by Printmanagement Plitt, Oberhausen
Printed in Germany

Serpentine Gallery
Kensington Gardens
London W2 3XA
T +44 (0)20 7402 6075
F +44 (0)20 7402 4103
www.serpentinegallery.org

© 2008 Nils Norman, Serpentine Gallery, London, and Koenig Books London

All rights reserved. No part of this publication may be reproduced, stored in a retrieval system or transmitted in any form or by any means, electronic, mechanicial, photocopying, recording or otherwise, without the prior permission of the publisher.

Disclaimer: Every effort has been made to obtain permission for quotations and images and the Serpentine Gallery would be delighted to hear from you with any information concerning works used.

First published by Koenig Books London

Koenig Books Ltd
At the Serpentine Gallery
Kensington Gardens
London W2 3XA
www.koenigbooks.co.uk

Distribution

Europe
Buchhandlung Walther König, Köln
Ehrenstr. 4, 50672 Köln
T: +49 (0) 221 / 20 59 6-53
F: +49 (0) 221 / 20 59 6-60
verlag@buchhandlung-walther-koenig.de

UK & Eire
Cornerhouse Publications
70 Oxford Street
Manchester M1 5NH
T: +44 (0) 161 200 15 03
F: +44 (0) 161 200 15 04
publications@cornerhouse.org

Outside Europe
D.A.P. / Distributed Art Publishers, Inc.
155 6th Avenue, 2nd Floor
New York, NY 10013
T: +1 212-627-1999
F: +1 212-627-9484
eleshowitz@dapinc.com

ISBN 978-3-86560-415-6

350265

Education Projects in 2008 supported by

Bloomberg

Charing Cross supported by

The New Patrons programme, supported by the Fondation de France, enables those confronted with questions of society or local development to associate an artist with this process via commissioning of an artwork. The originality lies in the collaboration of three players – the artist, the patron and the cultural mediator approved by the Fondation de France – and the support of public and private funding.

In collaboration with

Serpentine Gallery is supported by

709.05 NOR

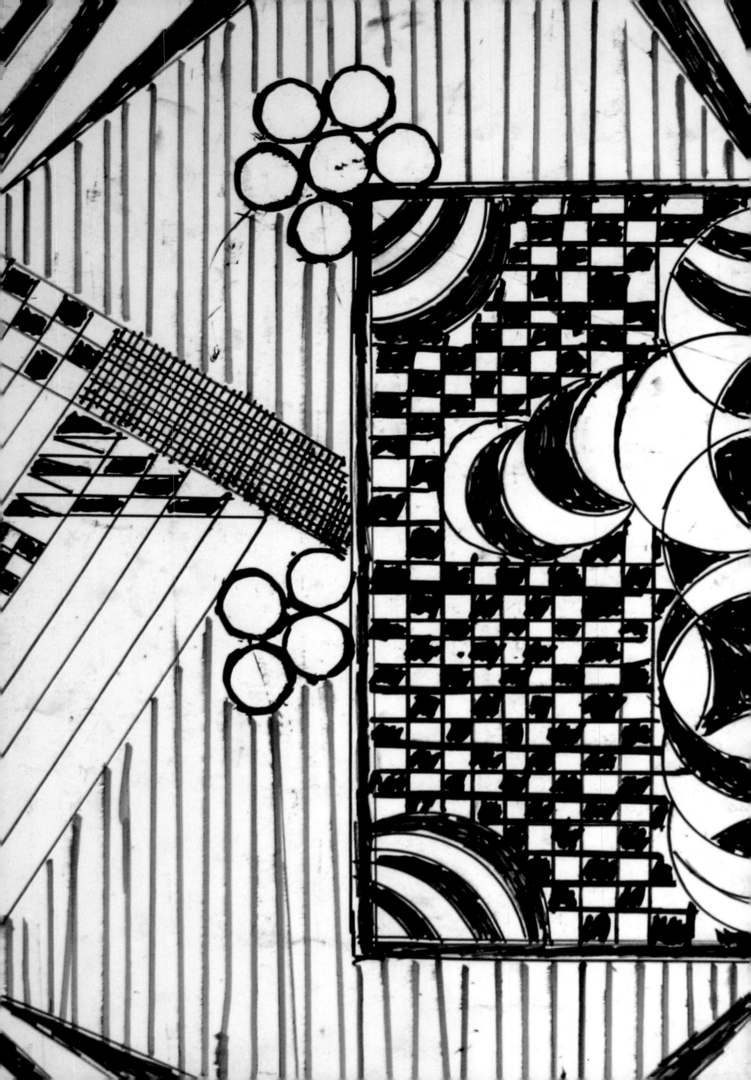